Table of Contents

The Business
of Advertising Photography

Professional Secrets of

ADVERTISING
PHOTOGRAPHY

Paul Markow

AMHERST MEDIA, INC. ■ BUFFALO, NY

Photograph by Ann Markow

Dedication

I want to thank my Mom and Dad who are responsible for this journey. Their patience and wisdom have allowed this wonderful life and career to happen.

Also, thanks to my wonderful wife, Ann, whose taste and style have helped polish me.

– Paul Markow

Published by:
Amherst Media, Inc.
P.O. Box 586
Buffalo, N.Y. 14226
Fax: 716-874-4508

Publisher: Craig Alesse
Senior Editor/Project Manager: Richard Lynch
Associate Editor: Michelle Perkins

ISBN: 0-936262-79-6
Library of Congress Card Catalog Number: 98-72977

Printed in the United States of America.
10 9 8 7 6 5 4 3 2 1

The publisher wishes to thank Frank McDaniel for his role in the inception of this book.

Image Making

Many photographers are wonderful at creating images for other people, and you may think this is the body and soul of our profession. However, before you have the opportunity to create these images, you must often create an image for yourself. There are many facets to this complicated and long-term endeavor.

First check into your personal image. While most photographers are by nature mavericks, your appearance is important. Since we deal closely with creatives and even some "suits," their perception of how you look can color the way they deal with you. Right or wrong, perception becomes reality. If you show up for an advertising job in a business suit and tie, your creativity will be immediately placed in doubt. Wearing a business suit with red Converse sneakers and pierced eyebrow will stand you in better stead. In other words, your look generally should have an edge, something that tells the art director that you can think outside the box.

Hygiene is obviously important. Spending the day with a photographer who has bad breath or body odor can be a nightmare for an art director. You are a hard working artist but you are also a service business. If your client has an unsatisfying experience either with your work, attitude, or hygiene, you will likely never work with them again. There is just too much talent out there for a client to put up with anything less than a completely enjoyable experience. While this may seem like common sense, I am amazed at the stories I have been told by dissatisfied art directors.

You must also create an image for your talent. Your style will dictate some of this. I've been asked frequently how to go about creating a style. I'm not sure there is an easy way. I've known many photographers who have worked long and hard trying to come up with some unique style. On occasion this process works, but remember this is a very in-vogue industry; the more unique your style is, the more quickly it is out of vogue. The world is littered with hot styles from Polaroid transfers to light painting. Current styles like cross-processing and selective focus will quickly evolve to leave in the dust those practitioners who can't change quickly enough. To me,

"Right or wrong, perception becomes reality."

5

a style evolves when you just like shooting. Something becomes comfortable, and one day someone walks up to you and tells you they love your style.

Advertising

Once you feel ready to show the world your work, you must find a way to advertise. This can be done in many ways:

• **Editorial Work.** One of the least expensive and traditional ways of getting exposure is though editorial work. Every city and area has a glut of papers and magazines – from avant garde to business – that is always looking for young talent who will work cheaply (often just for expenses). Not only can you pick a publication that fits you, but you get to push the envelope and experiment on someone else's nickel. This is a great experience and not only introduces you to interesting people, but also businesses that may need your services later on. You also get a photo credit, which never hurts. This is a great way to get started for the new advertising photographer.

• **Photo Directories.** If you feel you are ready to broaden your market from local to regional and national, directories may be your answer. The three most prominent directories are *Black Book*, *Workbook* and *Klik*. You enter these publications by buying an ad, usually a two-page spread. These directories are published annually and distributed to art directors and agencies, free of charge. It can cost anywhere from $5000 to $7500 for a two-page ad. You also need to plan for production costs (separations, design, etc.), which can easily run up the cost by an additional $1000 or more. On the other hand, most of these publications offer a variety of discounts for things like early contract signing, early art submission, and full payment in advance.

These publications will occasionally get you a job, but what they will more likely get you is a call asking to see your portfolio. You and several other photographers will then submit portfolios to back your ad in quest of a job. I, personally, have had great success with *Black Book*, averaging fifty calls per year. I consider turning 25-33% of these calls into jobs a good average.

Methods of Advertising
- Editorial work
- Photo directories
- Direct mail
- Cold calls
- Artist representatives

Remember, directories are like menus, they tell a client what he can expect from you. Just like restaurants, if you want a really good meal, you go to the place that specializes in what you want to eat. Directories are the same – art directors are looking for someone who specializes in a technique or subject they plan to use. For this reason, it's important to not just show your five best images if they are of different styles and subjects. Restrict your ad to a consistent style, subject or look. Don't mix table top with scenery, with fashion. If you do, no one will know what to use you for.

Regular direct mailings, in a high impact form such as this postcard, are an extensively used method of promotion.

• **Direct Mail.** Direct mail is another method that is used extensively. Some of the most original and exotic productions are presented through this venue. I have personally seen direct mail pieces that cost close to $100,000 to produce. There is much debate on the effectiveness of direct mail, especially in the shotgun approach where an art buyer or art director at an

7

important agency can be inundated with dozens of mailings per month. In direct mail, consistency and regularity count since the goal is that, over the long term, a photography buyer will start to recognize your name and work. My rep once commented that it was important to have your name big on a direct mail piece so at least the client will get a glimpse of it as they throw it into the trash.

There are two kinds of direct mail pieces. The "shotgun" approach consists of having, for example, 5000 direct mail pieces printed and sent to art directors in ad agencies with billing that exceeds $250 million.

The "target" approach is almost the opposite, where someone might make only twenty-five pieces and mail them to only a select group of people that they want to work with. The pieces should be mailed on a regular basis, as often as monthly, with follow up phone calls to targeted people. Targeted direct mail tends to be more exotic and memorable because producing fewer pieces allows you to spend more money on each. I believe target direct mail is generally more successful.

Because of the vast number of photographers that use shotgun direct mail, it is critical that your images have impact, design, and originality for the piece to be memorable. This is the only way to ensure a chance at success.

• **Cold Calling.** In the area of cold calling, it takes a special kind of person to get on a phone, dial someone they've never met, introduce themselves and ask to show their work. Photographers tend toward the less verbal side and usually don't fare well at this style of selling. However, I have a photographer friend whose policy it is to call several prospective clients each day. This is something he has great success with. So if you're one of the lucky ones who has no fear, this is a wonderful and more personal approach.

• **Artist's Representatives.** Once you have established yourself, you might feel the need to have an artist's representative (rep). If you are lucky enough to have someone in your life that has knowledge of the industry and loves to sell and negotiate, you can form a business partnership and grow together.

The elements involved in direct mail include:

- Choosing the photographs
- Designing the piece
- Printing
- Gathering or buying the mailing list
- Postage and labels

"...good reps are hard to find, and talented photographers far outnumber them."

If you cannot create your own rep, you will have to go out into the pool of existing reps to find the right one. A good rep is an invaluable asset.

Although "repping" can be a very lucrative career, good reps are hard to find and talented photographers far outnumber them. Because of this disparity in numbers, good reps are in the driver's seat. A rep may only have a few photographers and illustrators in his/her stable. They do not want photographers whose style or category competes with someone they already represent. When they decide to expand their roster, they look carefully to find people whose work is highly salable, or young talent that they feel is on the way up. They also want people they feel they can work with on a day to day basis. Remember, this is a business and not a personal critique. Reps want people they like, but even more importantly, they want people who enhance the bottom line. If a rep does well financially, so will you!

In choosing a rep, a photographer should first look for someone with the same business and life ethic you have. Reps are generally more aggressive than the people they represent – and you want that. But if you're a low key and gentle person, you don't want someone representing you who is loud and abrasive. Remember, a rep reflects you and therefore should be an extension of you and your personality.

Reps normally receive 25% of any fees they create for you. They also can receive 12.5-15% of your house accounts, but the decision to turn over house accounts to your rep should be done after careful consideration. Be sure the added service they are offering your house accounts is really worth the commission. Remember there is no such thing as a standard artist/rep agreement, so be sure that whatever the agreement, it is fair to every concerned party.

Most reps also want to be an integral part of your marketing, and some will share in this expense whether individually or in tandem with their other clients.

Portfolio

Your portfolio is one of your most important tools in getting that next job. Great care should be taken when deciding its design shape, size, weight, and context. It is your emissary and represents what you are capable of doing. While personally presenting your portfolio is always best, many times it will be sent to an out of town client or left at an agency desk. The most common portfolio seems to be made of black leather with your name embossed on it and usually contains approximately twenty images. These books can be ordered from a number of portfolio companies.

Remember, never show an image that is not up to speed. You will be judged by your weakest image. It is better to show only ten great images than to show those same images and fill out the rest of your portfolio with less wonderful images. Most art directors realize that your portfolio is your best work. However, they subconsciously take the weakest image and use it as the benchmark in judging the true quality of your work. If you show fifteen images that are a 7.5 (on a scale of 1-10) and five images that are a 6, the person reviewing your work will use the 6 as a basis for figuring the quality of work to expect from you. Your portfolio is only as good as its weakest link.

Many times you send a portfolio to an agency and you are in competition with many other portfolios. Periodically when I first started to do national work, I would find out that my book was coming up against photographers with much more name recognition than me. I felt that I had two strikes against me before my work was even reviewed. Knowing most photographers present their work in a standard portfolio, my wife (a designer) and I decided to come up with a portfolio that would even the playing field and give the art director as much anticipation about seeing my work as he had about seeing the work of the household-name photographer. Over several months we came up with a cowhide portfolio that unfolded into four pockets which held five images, each in leather mats. We also had a Navajo silversmith create a sterling silver buckle for the outside. We made five different portfolios in various leathers and made the leather mats interchangeable so we could customize our portfolio for the job.

"Your portfolio is only as good as its weakest link."

A unique portfolio can help your work catch the attention of a potential client.

Fifteen years later, it is still the best piece of promotion I have ever done. I am convinced many jobs we might otherwise have lost have been won and decided by the presentation itself. When an art director makes her decision, everything is taken into account, from your images, to the presentation, to how fast your portfolio is delivered.

There has always been a debate of what to present in your book – from mounted chromes, to laminate prints, to ads you've shot. I use 4"x5" duplicate chromes. Everything is duped to this same size, regardless of the size of the original. Never send originals. Remember, the end user of this portfolio is someone who is extremely busy. The more convenient and easy to view you can make your portfolio, the better. Don't show too many images – twenty is generally the maximum. Your portfolio should have a continuity that reflects one concise style and feel. It should be sent in a container that can be reused. Don't make the art director go searching for packaging in which to return your book.

You also need to consider weight. Check your express carrier for cut-off weight limitations. If you keep the weight of your portfolio in the lowest weight category, it is possible to save quite a bit of money over the life of a portfolio.

You should also consider having duplicate portfolios so, in the fortunate case that several potential jobs occur at once, you're not left making excuses.

Finally, never feel bad about asking someone who has requested your portfolio if they have an express carrier number to send the book. It is customary for the agencies to pay for the shipping of a portfolio in at least one direction. Most of the time they cover the cost for both directions. I have never had to pay for a portfolio to be returned.

Local business

Local business is the bread and butter of most photographers. Although I have talked primarily about national and regional work to this point, it would be a disservice not to discuss that all important local job.

All jobs are essentially local jobs, they just become regional or national when an out of town photographer is hired to shoot them. Therefore, local jobs should be handled in much the same way as national assignments. Even though it is a hometown job, don't *ever* underprice your work.

• **Agency Accounts.** Two main kinds of work exist locally: agency and client direct. Most reputable advertising agencies are fairly sophisticated in buying photography, but the size and experience of the agency needs to be taken into account. Some very small and new agencies need training. They may not know what really goes into making an image. For example, they may have seen a composite shot that looked easy. Yet, it may actually have been shot at a unique location with specialized talent and professional production that blends so easily it looks like the photographer just showed up and snapped a picture in fifteen minutes. They think you can do the same and want a corresponding cheap price. The reality is that it might have taken days to make this shot look seamless.

"Local business is the bread and butter of most photographers."

"... get as much information as possible about the person you are meeting..."

The image that the agency thinks should be created for several hundred dollars might in fact cost several thousand to reproduce. Analyze the shot before you quote a price for the job.

Make sure you educate the client to cost realities and what an inadequate budget will mean to their shot. Remember, no matter what you quote they expect the same results. Many small agencies run on a shoe-string budget – they may not pay you until they bill and are paid by the client. Getting paid by an agency can on occasion take months (90-120 days). Always check with the agency on how they pay, or just ask around. It is not undesirable to ask for an advance, especially when substantial production and lab costs must be paid within thirty days. I don't think that a photographer should act as a bank for any client.

Agencies on a local level should be handled by a phone call asking the art director if he might have time to view your work. Remember, art directors are usually very busy, so be prepared to be put off. I think gentle persistence is a plus. Don't bug, but do call back periodically until they can make time. Remember, they are doing you a favor, so don't expect them to drop everything for you.

It is also good to get as much information as possible about the person you are meeting: what accounts they work on, what interests they have, etc. The second kind of information is much harder to come by, but when you're in their office – look around. Look at the wall and desk, and try to find something that you have in common with this person. It could be a vacation picture to someplace you've been, kids' pictures, a golf trophy, or a favorite sports team you also root for. Start your conversation on a common topic, "Oh, I see you went scuba diving in Cancun. I was there last year. Wasn't it wonderful?" Make friends, then show your work.

Also, make sure to make friends with the receptionist. He or she is the most important person in the office, and usually underappreciated. Learn her name and thank her. When you call and say hello using her name, you'd be amazed at how much more easily you can get through to the art director.

You may also want to do some of the same things you do nationally. Direct mail works better locally, because art directors may already have some perception of you, and because you are local they think the chances of using you are greater. Consistency counts in direct mail. Plan on at least four rounds of mailing per year. Regional directories can also be effective and if you have a local rep he will keep your name out in front.

• **Client Direct Accounts.** Agencies and design firms have some of the best work, and high profile jobs with good creativity. The down side to these jobs is intense competition from other photographers and generally slower pay. Breaking into agency work can be very competitive for a photographer, while client direct work is less competitive. For these reasons, you should not overlook client direct accounts.

Some of my best and favored accounts are the bread and butter client direct accounts. Because many of them are low profile manufacturers or industrial businesses, they may often go begging to get photography. The furniture manufacturer may have 5-10 days a year of photography. They may not be looking for great creativity, but just want a wonderful rendition of their product. This means the client also may not want to see a highly creative portfolio. They are likely to be more interested in seeing product work or corporate work to which they can relate.

Many times you may not even be talking to a marketing department (although that's where you should start). Instead, you might actually meet the owner or general manager. Show them that you have done photography with products similar to theirs, give them a fair price, and more often than not, you will get a chance at their work.

These accounts, if serviced properly, require far less maintenance than agency accounts. As long as you treat them right, they will never go looking for another photographer (whereas agencies are always on the look-out for the newest talent). I have been told by local accounts that other photographers have approached them regarding work. I could tell that the client took some pride in informing the would-be photogra-

"Some of my best and favored accounts are the bread and butter client direct accounts."

pher that they worked exclusively with me. The other plus side is that client direct accounts pay upon receipt of the bill. I have several accounts who often pay me within a week of receipt of invoice.

If you're lucky and catch the business of a fast rising company, the occasional, or small, initial jobs could turn into a mountain of work from capabilities brochures, to product photography, to executive portraits and annual reports. There have been many times we have gotten a call from a client to do a very small job at a plant. Within a short time, however, the business and amount of work I've done for the company has exploded.

I have told young assistants that if they want to start working fast, drive to any good size industrial park with a portfolio and business cards. Call door to door at every business, and you will be working in no time flat.

The Job

The phone or fax rings and the art buyer or art director says he has a job he thinks you are right for, then asks you to send your portfolio. Upon hearing these happy words, I say "Great, where should I send it and where did you find us?"

"From the outset, I try to get as much information as possible about the project. "

From the outset, I try to get as much information as possible about the project. Is it location, studio, advertising or commercial, etc.? I try to sound enthusiastic about the project without sounding like this is my first time shooting. People want to know that you're interested in working on the project, and that it's not just another job but an interesting opportunity to do something gratifying.

• **Sending Your Portfolio.** After thanking them for their interest, I immediately (even if it's 4:30 PM) put together a portfolio specifically designed for what I think this job entails. I always send out portfolios the same day they are requested, and use express early-morning delivery service. Sometimes the first portfolio in establishes the lead that the others have to catch. I am always amazed when, after two or three days, the client states she is still waiting for portfolios. To me, this

shows an arrogance and says that the other photographers are not interested in the work.

~~Over the next several days we check to see if we can help~~ move the process along. This is a touchy area, since you don't want to bother them or look too desperate.

•**Finessing the Client.** In the course of my ensuing discussions with the art director, I also use what I call buzz words. These words let the art director know you have done this before and that you know how the game is played. Remember when the art director gives you a big job, his own job security is somewhat on the line. If you screw up, it's his rear end that gets chewed.

Usage is one of the key elements in determining the creative fee. While many photographers bill jobs on an hourly or daily rate, many times it is appropriate to consider the usage of your work when deciding your creative fee. An assignment might only take a half day to complete, but if your photographs will be running on the back cover of every publication in America, you would never charge by the amount of time it took to create the shot, but rather how many people eventually will see your image. For some, this is a hard concept, so I often use the analogy of the same song that is sung at different venues. If a singer performs a song in a small blues club that seats fifty people, they will surely be paid less than if they sing the same song before a crowd of fifty thousand in a stadium. Same song, same voice, same talent – different fee. Photography should be no different.

Production value is basically the amount of money that will be spent on the job (it does not include your photo/production fee). This could vary widely from instance to instance, and will be impacted by usage. Learning the production value of the project will play an important role in determining the amount of your bid, if you are asked to bid the job.

It can also be helpful to become familiar with the working style of the art director. Does the art director work with the photographer as a collaborative team, or does he just want you to be the mechanic? All art directors say they want the

> **Buzz Words and Phrases:**
> 1. Asking about usage
> 2. Discussing production value
> 3. Informing clients of the permits that might be needed
> 4. Discussing location and propping
> 5. Finding out the timeline for the shoot

photographer's input, but believe it or not, there are art directors who really just want you to produce their vision. Your input may be only minimally required or desired.

So when talking to the client, your knowledge, interest and input, as well as buzz words, let them know *you* are the person to use. But remember, don't give away sensitive information before you've gotten the job. I once informed a client of a wonderful little-known location before being awarded the job, only to not get the job and later find the other photographer was told of a great place to shoot – mine!

• **Making a Bid.** When you finally get the call saying they loved your work and would like you to bid the job, you know you're in play. The contest has been narrowed down from as many as twenty portfolios to you and one or two others.

> "... it's incumbent on you to troubleshoot the job over the phone."

They may or may not send you layouts for the bid, so it's incumbent on you to troubleshoot the job over the phone. You need to think of any thing that might occur, and budget for it. The quickest way to lose an assignment is to forget to budget for an integral part of the job that the art director is aware of. They will usually cross you off the list because they think you haven't thought the project through.

One element that should be considered in determining your fee is what I call it the uniqueness level of the image. If you are being asked to shoot a simple image (say a black and white head shot of someone, with straight ahead lighting on white seamless), the image called for might not be hard to create. In fact, there are a number of photographers who could produce a similar image. The resulting competitive situation may well drive down the fee compared to a unique image or style that only a very few photographers can create.

As the bid and negotiation portion of the process gets further along you should start to get a feel for where your bid should fall. Hints and subtle guidance by your client can help guide you to the desired end.

It may be somewhat controversial and is strictly my opinion, but I believe that most art buyers and art directors have

already penciled in what the photography portion of the project will cost. It is therefore your job to get as close to this number as possible, without going over it. This is controversial because most photographers want to believe they set the price. In reality, for most projects to even get started, the agency must fly numbers by their client. Usually only after these numbers have been approved can the agency go ahead and bid the job. They know through experience what their project should cost. For example: $10,000 for the creative fee and $8,600 for production. They want you to get as close to the $8,600 as possible. That way they know that they are getting maximum production value. If you bid above that amount, it might come out of the agency's end of the budget, or they might have to go back to the client to request more money – something that the agencies don't like to do.

At some point in the bid process, you might be told you are their favorite and in the lead. Don't always believe this. When comparing notes with other photographers, I have found very often that we were all told we had the lead. I believe that this stems from the client trying to make everyone feel good. This sometimes also accounts for the art buyer and art director telling you that you lost because the other photographer underbid you. In truth, many times only a few hundred dollars separates photographers on a bid. The reason for their choice could be that they liked your voice on the phone, or just liked your work better, and so made sure that you won the bid. The bid system is one that art directors tend to appreciate less than the financial types who mandate it. So don't feel bad or blame another photographer for screwing you out of a job. The reason for winning a bid is sometimes just a mystery.

"The reason for winning a bid is sometimes just a mystery."

Production

The phone rings and your client is thrilled to be working with you. They loved your portfolio – you were always their first choice! Now comes the scary part: you actually have to produce and live up their expectations.

You are only as good as the team around you. Production is the single most important element in the success of a shoot. The more organized and buttoned-down you are, the easier

and more fun the actual shoot, and the better the results. My team starts with my studio manager, Jennifer. Her organizational abilities keep me afloat. Her love for detail and talking on the phone perfectly complement two of my weaknesses. Production could be a book in and of itself, so I will try to succinctly give you a lay of production land.

Production Elements Include:

• Location scouting
• Obtaining permits
• Prop and set stylists
• Hair and make-up
• Photographic assistants
• Production coordinators
• Casting
• Models

•**Location Scouts.** Scouts can be found in almost any metropolitan area. The film commission for each state usually is a wonderful source for local information. Listings for these commissions can be found at the back of this book. Local scouts may only be familiar with their area or a certain part of the world. By explaining to them exactly what you are looking for or showing them layouts of what you need in terms of landscape, a good location scout will go out and find exactly what you need. They will give you a complete set of panoramic pictures of several locations that are appropriate along with permit requirements, cost for location fee, where and when the sun rises and sets, and anything relevant to choosing your location.

•**Permits.** Permits and location permission are a sorry fact of photographic life. Permits can be quite complex with pages of forms to be filled out, faxes to be sent, bonds to be set, insurance certificates to be requested and fees to be paid. You must first determine who has jurisdiction over the land you wish to use – National Forest Service, National Parks, State land, private land, Indian Reservation, etc., and then contact the appropriate party. Sometimes two parties have jurisdiction, for instance when you shoot on a state highway (Department of Transportation) that goes through a National Forest (U.S. Forest Service). The owner of the land will generally require you to have an insurance certificate, typically a $1,000,000 liability naming the party additionally insured. There is generally a fixed fee on government land; price is a little more negotiable with private property individuals. In many cases, you are required to hire additional personnel to help protect you and the environment. These additional persons could be forest rangers, police, Indian guides or scouts. This usually represents an additional expense. There is almost nowhere left on the planet where you can shoot commercially without some sort of permission. From city streets and parks, to office

buildings and even the most desolate piece of land, someone will be out there asking to see your usage permits or with their hands out requesting some sort of compensation. If you have not been caught yet, consider yourself lucky. If the job is critical enough that you can't chance being thrown out, get that permit. If, after publication, a location is recognized which required a permit you did not obtain, you could be sued.

• **Stylists.** A stylist can be critical to a job. There are food stylists, fashion stylists, wardrobe stylists, hard goods stylists, soft goods stylists, and set stylists. These are the people who gather the props, clothes, food, etc., either by renting, buying or drawing on their large collections. They will help design and prop your set, steam and iron the clothes, prepare and style food, and find the right set of books to put on the right night stand in a white sale catalog. A good stylist will not only find the right color props to complement your location, but also find the right period of props from the 30's to the 40's, to disco or into the future. Some photographers love propping their sets and some are well known for it. If you don't have the talent or time, a stylist is an invaluable member of the team.

• **Make-up.** Most people feel make-up is just for the fashion industry. However, makeup can make a large difference in almost any photo shoot. A good make-up artist can really improve the overall look of anyone. One area that is often overlooked in make-up is its use when photographing executives. Men, unlike women, almost never wear any corrective makeup. While a woman might show up in poorly done make-up which needs to be completely redone, men, except for shaving and combed hair, show up the same way as if they rolled out of bed. This includes chapped and dry lips, dark circles under the eyes, blemishes, sunburned faces from the golf game the day before, and oily or dry skin. While it is somewhat difficult to convince male executives that make-up is a plus, once they see the results, they are converts. They look so much better! I have even had former accounts call us to ask where they can find the make-up artist from the previous shoot. I have had as many as three make-up people for a board of directors where time was of the essence. The older and more flawed the executive's appearance, the more you will notice the improvement when make-up is used.

"... once they see the results, they are converts."

"How do I get this often conservative group to have make-up applied?"

How do I get this often conservative group to have make-up applied? First, I tell them it is just like retouching, but more natural. Second (and this may sound chauvinist), but I always use an attractive female makeup artist on executive men, male sports figures, and entertainers. This accomplishes two things. First, they are less resistant to having the makeup done. Secondly, and more importantly, men who are in high-powered positions are usually more aggressive than the general public (a factor which can effect the photo shoot). However, they tend to be on their best behavior around attractive women, so I use this flaw in men to my advantage. It usually buys me a little more time with them than I might otherwise get, and helps level out the testosterone level. Bottom line – I get a friendlier shoot, and better final results.

Some makeup artists also do hair, and generally clients will only want to spring for a combination hair and makeup person. Only on really large shoots do clients actually budget for separate hair and makeup artists.

• **Photographic Assistants.** Today most photographers use assistants. There are two kinds of assistants: freelance and full-time. I have used both extensively, and both have their advantages. The freelance assistant is one who works for various photographers. He is paid anywhere from $75-$300 a day depending upon the city and his skills. These costs are generally added to the total bill, but must be budgeted for in the original estimate. Some photographers make a mark-up on their assistants. I have never believed in this particular mark-up, but it does go on extensively.

The advantages to using a freelance assistant are two-fold. On a financial level, you are not responsible for the variety of taxes on payroll that regular employees incur – no FICA withholding, social security, etc. You only incur cost when she works, and this is a billable cost to the client. Secondly, you can hire an assistant who has specific skills for the job. For example, some assistants work primarily on cars. If you do get that type of job, some assistants know as much as you about shooting vehicles.

The ability to hire a specialized assistant can complement your knowledge of the job. If you are traveling out of town, a good local assistant knows the lay of the land, where the labs, prop houses, modeling agencies and restaurants are located. They also know how to get around town. While freelance assistants get wonderful experience by working for a variety of photographers, they usually learn little about the business and marketing side of the profession. Once a job is complete, they go on to the next photographer and project.

In-house assistants, on the other hand, may not get the rounded photographic knowledge of their counterparts. A full-time assistant can work for you anywhere from six months to a year, and some become permanent employees of the business. Unlike freelancers, though, in-house assistants learn all the little quirks of the photographer and his equipment. They can be the best assistants because they know your likes and dislikes, how you generally light a shoot, etc. Most high-end photographers have at least one full time assistant, called a first assistant. They will supplement that assistant with freelance or second and third assistants. The first assistant's job is not only to assist, but also to manage any other assistants working on the set.

Long-time assistants will know their photographer, and do most of the basic lighting and film and exposure tests. The photographer may only show up just before the shot and do some minor tweaking and shoot the job. For some big-time shooters, the assistants are salaried and paid fairly well. Some assistants make the decision that they love photography, but are not cut out for the final decision making and business responsibilities of the profession. These assistants become career assistants, and if they are fortunate to work with high end shooters, will have lucrative and exciting careers.

I usually want a full-time assistant to stay no longer than two years. At this point they have learned most of what I can teach them, and if they are any good as photographers, they start to "stale." I pay full-time assistants a little better than minimum wage when we are not on a job, and just working around the studio. They do, however, get paid full assistant's fees when

"... a specialized assistant can complement your knowledge of the job."

on a shoot. Because most assistants today get paid between $100-$150 a day, in many cities they can live reasonably well making from $25,000-35,000 a year. While I don't begrudge this pay to them, for I believe they earn it, the decent wage acts as a double edged sword. While a good income enables young starting assistants to live comfortably, it also hinders them leaving the assistant's nest to face the uncertain and very competitive world of this profession.

I sometimes believe it might be better to underpay assistants, and force them to learn, and become working photographers as soon as possible. I have seen several talented people become far too comfortable in the netherlands of assistant-dom and fail to make the jump out of the nest and go it alone. Unfortunately, I have no resolution for this, other than to observe that the most fearless and strongest will move on.

"A production coordinator gathers all the people needed to get the job done."

•**Production Coordinators.** A production coordinator is sometimes the person responsible for doing most of what precedes the shoot. This person can come in the form of a studio manager or a freelance production coordinator. Although a studio manager has far more duties along the business end of the studio, I will, in a production sense, lump the two together. A production coordinator gathers all the people needed to get the job done. She will organize, schedule, make sure crew and models show up at the right time and place, order food, make hotel and plane reservations, reserve car rentals, hire additional crew, and all the variety of things that must run on time for a shoot to go off as scheduled. From the smallest detail to the largest, a production person covers everything the photographer does not need to handle personally.

In my thirty years of business I have had good and bad studio managers. A good studio manager makes it a pleasure to show up at work and complements my weakest points with her strengths. For instance, my current manager, Jennifer, is detail oriented. Whereas being on the phone endlessly making those good and bad calls bores me, she loves it and is far tougher with people than I tend to be. I just like to shoot.

There's a reason photographers generally are not great business people; we got into the business to shoot first and make

money second. Surrounding yourself with a good team is one of the best ways to ensure success. Don't try to do the things you either don't like to do or aren't qualified for. All the best and biggest photographers have wonderful and efficient teams around them.

Rent or Own

In today's expensive and changing world, it is often better to rent than own. Traditional and especially digital equipment changes so fast you can never keep up or amortize the equipment before it's obsolete. Having a studio can also be a tremendous burden time-wise and financially.

Although I have more equipment than most, I have always tried to own only the equipment I use constantly. The exotic lenses (big glass), "tilt and shifts," etc. that are only needed occasionally are far cheaper to rent. Some photographers need a studio of their own, but if you only sporadically use one, it might be better to rent. Sometimes studio rental can even be a cost of the job that's billable to the client. Remember, when you wince at the cost of a studio rental, every photographer who owns a studio is in effect paying a studio rental fee on every job she shoots. This fee is considered fixed overhead, but it is defacto studio rental.

Many major photographers own very little equipment, possibly only their camera. All other equipment such as lights, booms, stands, clamps, etc., are rented on a per job basis. It also pays to rent equipment you are thinking about buying and field test it to make sure you've made an accurate match of equipment to your needs. I have more stuff that I have bought on impulse that rarely, if ever, gets used, than I like to think about.

"It also pays to rent equipment you are thinking about buying ..."

Staying in Business

The most important thing in producing jobs and taking pictures is staying in business. A fellow photographer once told my wife that the thing he respects most about me was that I have been able to stay in business so long. My first reaction was to be somewhat insulted – how he could not first respect the quality of my work? Over the years I have grown to appreciate that as the ultimate compliment I hope it was.

Having made probably every mistake in business (short of tax fraud) you can make, I would never be on anyone's hit parade of top business people. I do know, however, that this is not art. Art is for the few lucky people born into money, or able to live on virtually nothing – people who can explore their vision without regard to commercial viability. Advertising photography today requires great talent and elements of artistic ability, but it is really a service business. Our job is to produce the best possible photographs within budget and time constraints, while affording our client a pleasurable working experience. Too many photographers think they are owed something by the industry, that the client should bow down and thank their lucky stars to be able to work with them. Being a prima donna only floats as long as no one else can do what you do. When that day comes along, clients will fly to the friendlier skies of your competition.

Accounting practices are pretty standard and should be followed consistently. Here are a few business practices that have stood me in good stead over the years.

•**Pay on Time.** We always pay our vendors the day we get paid, or at thirty days. This includes assistants, stylists, talent, make-up crews, labs and photo supply houses.

I have seen too many agencies and photographers get in financial trouble when checks come in as payment for a job and they retain the entire sum for their for their own use, even though they owe the people they hired for the production of that job. Don't make the same mistake. Once you bank a check and hold on to it for a couple of weeks it becomes very easy to lose the distinction between what money is yours, and what belongs to the people you hired. It feels as if it's all

"Advertising photography today ... is really a service business."

25

yours. You see a lump sum in your checking account and that strobe system you always wanted looks affordable. If you make the purchase, you will have spent someone else's money and will have to find some way to pay them. This process can be insidious, and before long no one will want to work with you. Remember, part of the check is not yours. If you pay the people as soon as you get paid, it doesn't hurt as much. This is a small industry and the word gets out fast on the streets as to which agencies or photographers are slow to pay (or may never pay).

•**Sometimes it Pays to Sue.** Every few years some client will blatantly try to screw you. If I feel a client is not making a good-faith effort with me, I will spend good money going after bad. This is a matter of principle, but also lets others in the industry who might be similarly inclined know that you won't just roll over. I have used this tactic four times in my career: three times with a lawyer and once in small claims court, where I froze a large theater's bank account for three days until they paid. Despite posturing from several larger agencies, I have always won these lawsuits.

In order to prevail legally you must always have good documentation including a PO# or other proof that the job was given to you, and a signed delivery memo showing that the client received the work. I always try to give the client the benefit of doubt. By having a paper trail to prove what was said, you can usually stop conflicts before they happen. Be sure to write down what you quoted and the client approved. Make sure that your client has signed your estimate.

Learn the fundamentals of good business and you will not spend your career in a tangle of paperwork problems. I try to run my business by the golden rule, treating my clients well and expecting the same in return.

Almost anyone can pick up a camera, print business cards and claim to be a photographer. It's the business of being a photographer day in and day out, servicing my clients, providing the best possible image that I can, and treating my clients and crews with respect that has kept me in business for so many years.

"... you can usually stop any conflicts before they happen."

Images and Techniques

Finding the location was the hardest part of creating this image. I had to locate a wide-body jet that I could shoot inside of. It would have been possible to shoot on a movie set with a jet that had been constructed for use in a film, but I wanted the more authentic look of a real plane. Additionally, shooting on a real plane was much cheaper. The solution turned out to be shooting in a warehouse in Arizona where planes are stored. We could have rented just about *any* kind of plane there.

• **Location Scouting.** Finding the location for a shoot is usually the responsibility of the photographer. Demonstrating to clients that you can quickly and accurately find the right spot is an important part of proving your skill and professionalism.

Most of the job of location scouting is simply a matter of following leads. The yellow pages are always a good place to start. If you were looking for a plane, you might call the local airport. Even if they don't have a plane, they may have an idea where to look next. The same principle applies for tracking down props. If you needed an art deco chair you could start by calling large antique stores. They may not have one, but might point you to a known collector of art deco furniture. The collector may provide you with the name of a supplier. It's all very investigative and requires a good deal of leg work, but I find that people are usually very willing to help – especially when you tell them why you're looking.

• **Budget.** Budget plays a role in how long you'll be able to spend searching for a site, as well as the region in which you will want to search. A client with a limited budget may not be able to invest much in travel or accommodations, so a local or regional search would be in order. For a shoot when money is no object, you may be able to scout the whole world for precisely the right location for the perfect shot.

Larger budgets may also make it possible to use a professional location scout and provide him with very specific parameters (for example, a tall waterfall with a narrow stream against red rock cliffs with a ledge in front of it to park a car). You will also want to specify the permits you will need, as well as the money you have available to spend on location fees.

"Finding the location was the hardest part of creating this image."

Swift Trucking wanted to show their relationship with Mexico in this image. To accomplish this, shooting at a border crossing where a Mexican driver switches in for the American driver seemed a good choice.

The tricky part was to find an interesting border crossing that would be instantly recognizable to the viewer. The crossing we chose was visually interesting because it was at a bridge, and identifiable because a sign indicated the country.

• **Coping with Adversity.** We arranged permission to shoot at this crossing, and everything seemed to be set. Unfortunately, when we showed up, it turned out that the bridge was closed to 18-wheeler traffic! We spent hours trying to work out an arrangement, since this was the only appropriate border crossing we had found.

• **Creative Solutions.** Our two choices were either to pay up the money the officials wanted, or (the option we took) to use a composite image. The two photographs at the bottom of the opposite page were combined digitally to create the final composite image (the photograph at the top of the opposite page) used by the company in their ad. The bridge was shot from a hotel room. I then went down below the bridge and shot the truck about two minutes later. This ensured that the light would match in the two images. Some photographers may feel threatened by digital imaging, but in this case it provided a solution to a tricky (and potentially costly) situation.

"... two images were combined digitally to create the final composite image ..."

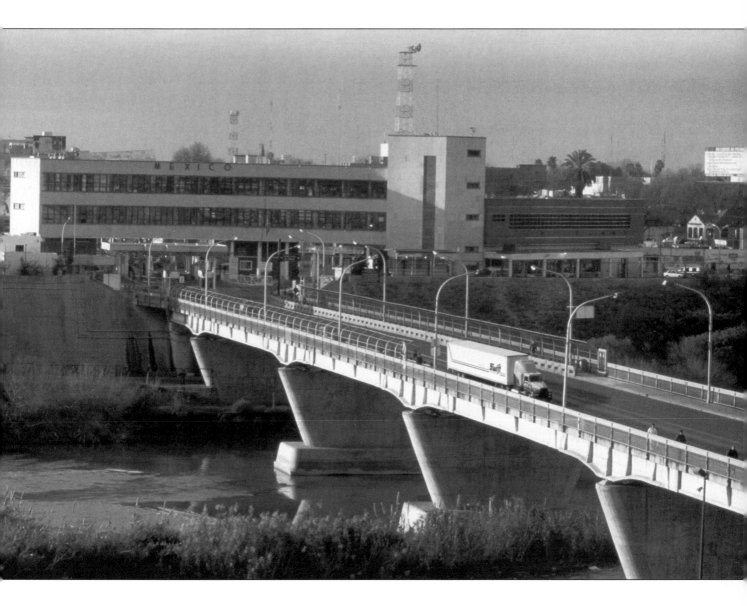

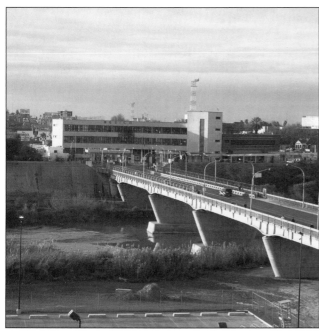

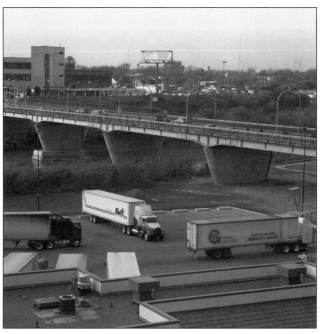

This photograph was shot for a linen brochure, for which I was trying to create a very different, hip style. I used very selective focus (notice how little of the image is totally sharp), and unusual angles. The shot was lit with strobes and a softbox shooting down from the top. A curtain of parachute material was placed to the right with three strobes shining through it to create a soft, but not muddy, effect.

• **Keeping Current.** Five years ago this style of image would never have flown for the same catalog. Now, they were extremely pleased with it. It's very important to keep up on the most current styles. Like most photographers, I'm a magazine junky. I use them to keep current on what is being done and to get ideas that I can incorporate into my own images.

• **Capturing a Mood.** Although this photo looks like it was taken on a perfect summer day, this was not the case at all. Conditions were miserable – the day was extremely hot and humid. The important thing to note, though, is that the camera doesn't show that. One of the most crucial things we must do as photographers is keep in mind that that camera is completely objective, and it is our job to make it subjective. Imagine yourself out on a picnic, shooting pictures of a person you are madly in love with. The birds are singing, there's a cool breeze blowing, you smell the fresh flowers, you drink some wine, and as you shoot you think that this is simply the most beautiful thing you have ever seen. When you develop the pictures though, suddenly the scene just doesn't look as good. What happened? Well, the sound of the birds is gone, the cool breeze is missing, as are the wine and the flowers. It's important when shooting that you not let your eye get clouded by other sensations, be they good or bad.

"It's very important to keep up on the most current styles."

The assignment for a band called "Frank Lloyd Vinyl" was to shoot images for use on their CD cover and posters. The group had made up a word "fondo" for the CD title. They defined the word as a person who spends a great deal of time and energy on a project that he believes is wonderful, but that no one else can quite understand. We had to depict "fondo."

• **Finding the Art.** The art director wanted to do a shot of a person who looked like "trailer trash," and was holding something completely useless. The hardest part of the project was to find the objet d'art that would work, without offending the artist. My studio manager was able to find an artist who had many sculptures in his backyard made from recycled materials. These formed the background of the photograph.

• **The Model.** We hired a model, told him to grow a beard for five days and bring his most offensive clothing. He really got into the job, and while browsing at Home Depot, spotted these ruler suspenders.

• **Photography.** I shot the image at dusk (fifteen minutes after sunset) with a Canon 35mm lens to add comedic distortion. Since the subject was so absurd, I lit the background with six lights all gelled with garish colors. The subject himself was lit with one soft box with a 1/2 CTO for warmth. The whole thing was shot with a 1/2 second drag shutter. For a more detailed look at this technique, turn to page 88.

The finished shot was exactly what the group wanted.

"We ... told him to grow a beard for five days and bring his most offensive clothing."

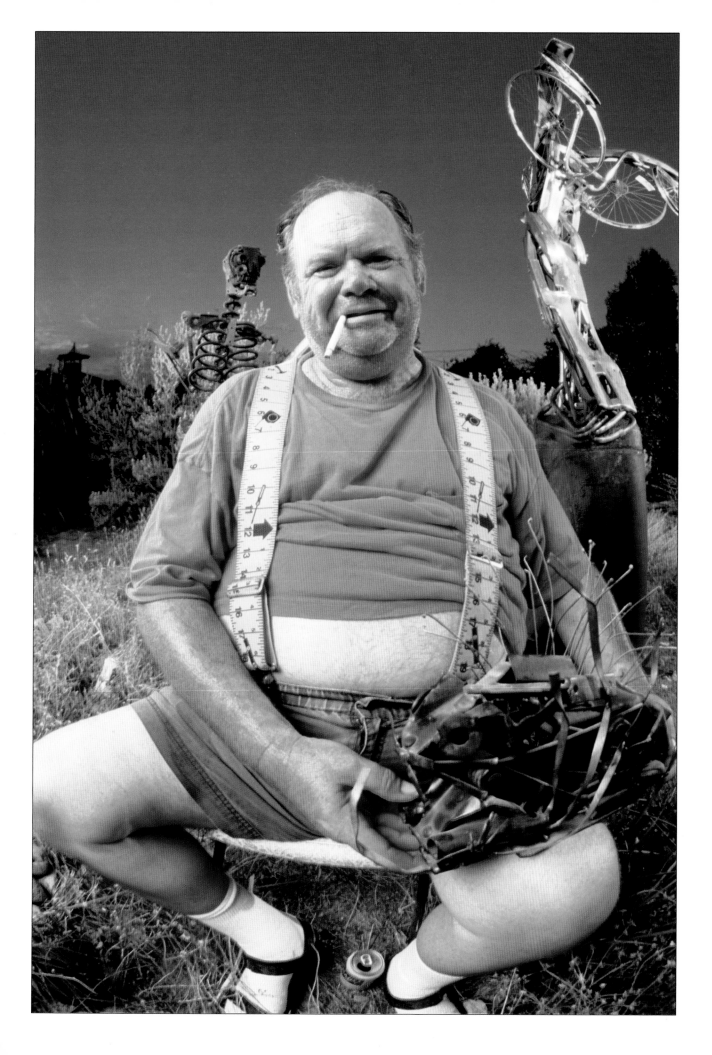

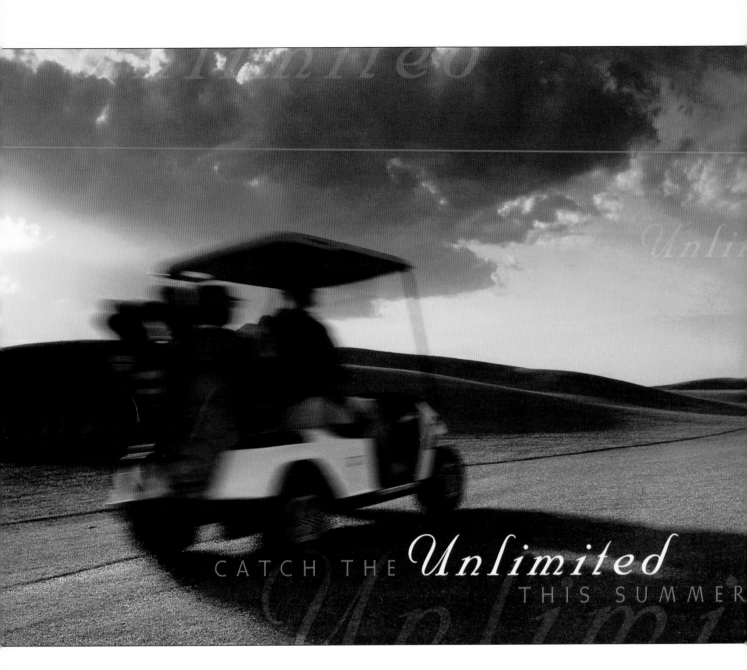

CATCH THE *Unlimited* THIS SUMMER

"... it's not just taking a great photograph that gets you the jobs ..."

This was a promotional image shot for Carmel Valley Ranch, which is a very lush location. The shot, however, was taken in Arizona. In order to make the photograph look authentic, we had to find a location where no desert or trees were visible. In addition to good location scouting, blurring the background makes the location even less identifiable. This motion was accomplished in two ways: by panning from the ground, and by pacing the golf cart in a second cart.

• **The Business.** When getting started in advertising photography, one of the biggest mistakes I made was in money management. I was making a lot of money, and having a great time, but I was a terrible businessman. For anyone getting started in this profession, I would recommend that you educate yourself on the business aspects of the field, or make sure to get people working for you who understand business and money management.

• **Developing an Image.** The point in my career at which things really began to happen was when I realized that perception is reality – that it's not just taking a great photograph that gets you the jobs, but convincing people that you have what they want. The realization came when a big name photographer rented my studio for a shoot he was doing. The shoot took five days, and was an illuminating experience for me. Despite the art director's bragging about this photographer, all of his work was essentially done by his assistants and the images were nothing at all special – no special lighting, or energy, or excitement. Despite this, there were five people on the site, plus the model, to take the image. We estimated the whole shoot (including stays at the best resort, rental cars and first class air for all involved) cost the client about $78,000.

After I saw this I went to my local rep and told her how silly I thought this was. She agreed. That's when I decided that, if people have the money to pay for this, then I want my share of it. That's when I really started working on my image. I put together a new portfolio (see pg.11). I started marketing myself, and I got a New York City rep. Although I don't want to move there, having a New York City representative associated with my name gives me a perception of quality and makes people take my work more seriously.

The company that was doing this ad had almost no budget to work with, so we had to be creative. First, the shot was done with two non-professional models (one is a fireman, one the girlfriend of a musician I had previously shot). This makes the ad look very real. The company's business is installing computers in hotel rooms, so they wanted the look of a hotel room. To cut costs, we were able to shoot the photo in a model apartment in a housing complex. The scene was lit by strobes coming in through the window. The screen of the computer was also burned in during the shoot. By using lots of angles, and even a fashion tilt, an image was created that looks natural and contemporary. The whole shoot took about two hours.

• **Rights to Images.** Unless otherwise granted in the contract, I retain the rights to all the photographs I take. This means I have the right to sell all the images from a shoot. My clients then buy the rights to use the image for a specified length of time and for specified uses in specified countries. It is important to keep good records of this. For every sale, you should have a signed purchase order showing precisely the usage of the image and the amount billed for this. You do have to do some policing to make sure that clients only use the images in accordance with the rights for which they have paid. I don't go out of my way to track usage, in general, but there have been times when I have come across an image of mine being used without my permission. In that case, I have to call them on it. Generally, getting paid for the additional usage isn't a big problem since advertising agencies don't want to risk being sued, and certainly don't want to look dumb to their clients.

"... this ad had almost no budget to work with, so we had to be creative ..."

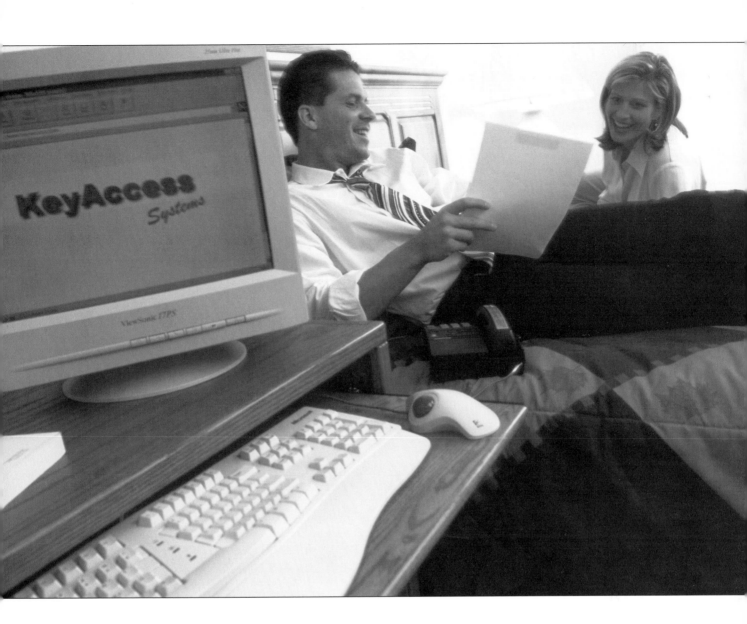

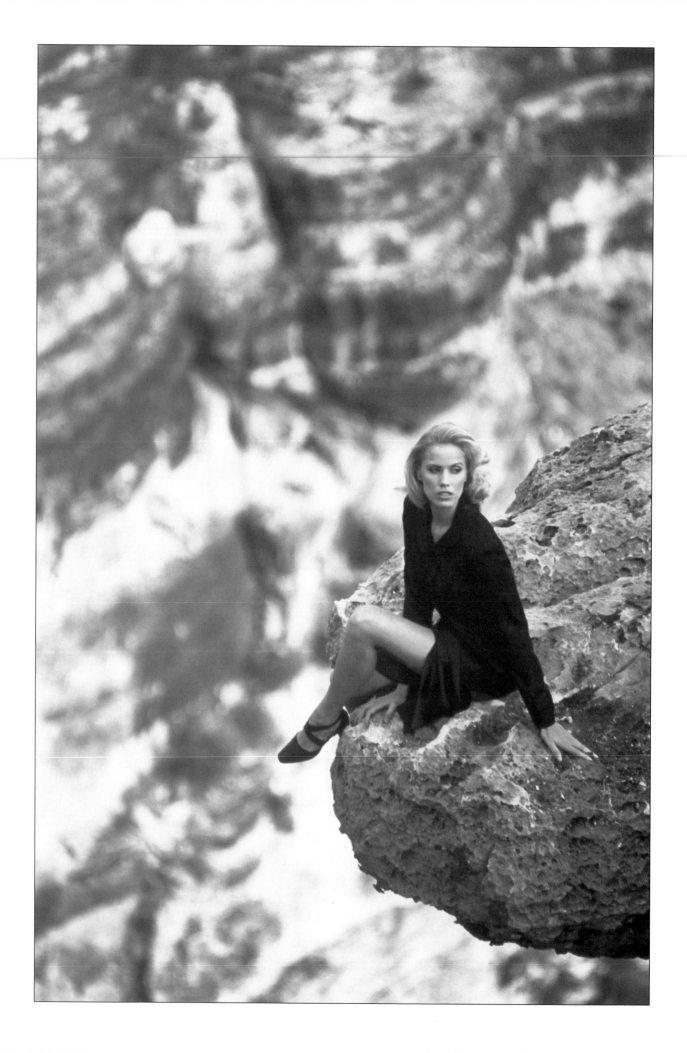

"Something like this is very good for business ..."

This image was shot as part of a film test for Eastman Kodak. They told me to pick a shoot, and they would come out. I selected this location in Northern Arizona and two models. Everything was shot with three different films. Something like this is very good for business, especially since the image ended up being used in Eastman Kodak's show booth in New York for two years – with my name on it.

• **History in the Field**. I grew up in commercial photography. My father's studio was in our house until I was about ten; then he moved it to an outside location and was quite successful. I spent my time after school and on summer vacations mixing chemicals and learning the business. I also went out on what I call "grip and grin" jobs – those terrible pictures shot at conventions with two executives shaking hands. I shot weddings, too, and found it a far more stressful kind of photography than advertising, since every shot is a once in a lifetime opportunity. I learned the business while working as an assistant to my father for fifteen years, and then took over the commercial business in 1982.

Just when you thought it couldn't get any worse...

One of the first shoots I ever did was a photo for two local fisherman whose big catch won them a space in the local paper (a shot they used to get some free advertising for their printing business). Everything that could go wrong did. The fish had been stored in an undersize freezer and when they arrived were frozen in a horseshoe shape. We tried to thaw them in warm water, but as you can see, it was only partially successful. No one had thought to bring rope to string up the fish, so we had to use a garden hose. It was also a terribly hot day, so the final photo featured two sweating men struggling to hold up a bunch of bent fish on a hose.

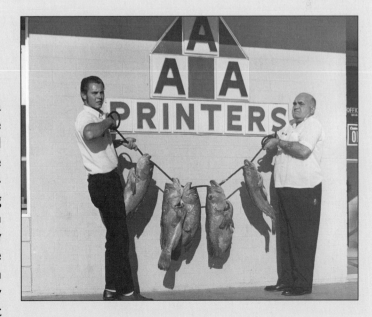

41

It always pays to keep your eyes open and have a camera with you. I was on vacation and came upon this great scene of senior men in a triathlon. The image has sold for stock usage, and is something I have used in directory listings.

• **Selling for Stock.** Since I own the rights to all of my images, I also sell many of them for stock. This used to be a big part of my business (about $3000-4000 per month), and is something I intend to get back into more heavily. There are a lot of great photographers doing stock right now – and many of them do only stock photography. Because clip art has cut into the market, stock photographs really have to be one of a kind shots. Stock photography now features the latest, hippest techniques, such as Polaroid transfer, cross-processing and selective focus. When I'm on an assignment for a client, if it looks like I can get some good images for stock, I will ask them to let me take a few shots without the product. I also get the models to sign a release, and they get 25% of the fee if the image later sells for stock.

Stock photography can be very lucrative. For instance, I had the chance to shoot photos of the World's Best Santa Claus (according to *National Enquirer*). I shot for one hour and have since made about $100,000 on the sale of the image. I still send the man's widow about $5000 per year as her husband's 25% cut. Hour for hour, stock photography can pay out more highly than anything else, and provide a nice regular income to help you cover your expenses.

> "Stock photography now features the latest, hippest techniques ..."

Hints & Tips
I do a little bit of every kind of photography – food, fashion, cars, industrial, architectural, etc. Although versatility is certainly an asset in photography, the fact that I haven't specialized has hampered my career somewhat. This is because the biggest companies tend to hire photographers who specialize in precisely that company's style (for instance, Nike wants pictures that look like Nike pictures). They want someone who *only* does that. By being non-specialized, though, I can go for a wider range of jobs, and I keep myself interested in what I do.

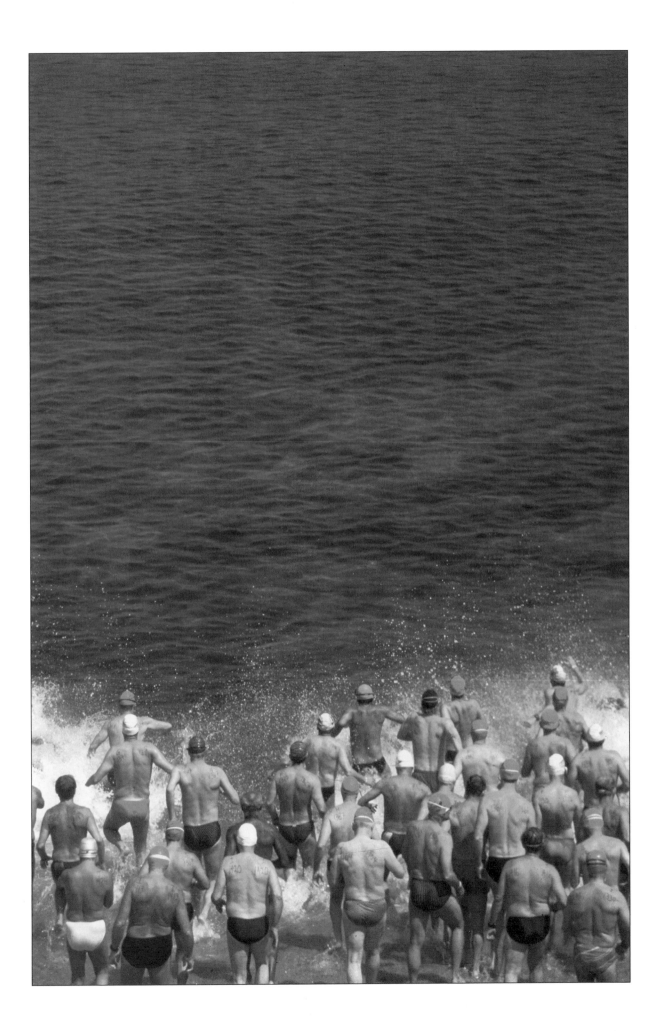

This image was commissioned by William R. Morrow Publishers as the cover for a book by Rosemary Altea, a spiritualist author. This is a job that came out of my listing in *Black Book*. The author was in Arizona at the time and had found this spot where she felt a strong spiritual convergence. She wanted her cover photo shot here.

• **Being Flexible.** This shoot was another example of having to be flexible when the unexpected happens. When we scheduled the shoot we expected to have three hours of good light in which to shoot. On the day of the shoot, however, the author and her escorts were late. We had only fifteen minutes of light in which to get the image! Given more time, you always feel you can improve a shot. We made the best of our short window of opportunity and created an image worthy of the cover. Ultimately, that fifteen minute shoot has paid off in $2500 for US hardcover rights only. For every new country in which the book published, I receive an additional $750 for the rights.

Here, the unexpected circumstances didn't turn out to be too much of a problem, but on other occasions, we have had to cancel whole shoots and reschedule. I was once shooting in Telluride and had rain for five straight days. Finally, we just had to give up, and everyone flew back home. When the weather cleared up, we went back and did the shoot. In a situation like this where you spend a day (or more) waiting to shoot, you may get paid your full day's fee, you may receive a half-rate, or you may get nothing at all, depending on the client. Weather is just something you can't control, especially if the image calls for sunlight. You can fake the look of sunlight on a small scale, but not a whole sky. The solution may be to switch locations, or to make an executive decision to reschedule. The important thing to do when a problem like this arises is to keep your client informed of his options.

"This shoot was another example of having to be flexible when the unexpected happens."

PROUD SPIRIT™

Lessons, Insights & Healing from "The Voice of the Spirit World"

ROSEMARY ALTEA

Author of the *New York Times* Bestseller
The Eagle and the Rose

I was basically a mechanic on this shoot, since the art direc-tor had a very precise photograph in mind. There wasn't money in the budget to accomplish the necessary effects dig-itally, so they all had to be done in the camera. Therefore, the main challenge of the job was to find the right truck, and the right location. This was harder than you might initially think.

"This was harder than you might initially think."

• **Location Scouting.** First, the shot called for an 18-wheeler with a sunset behind it, but also showing under the truck (see the artist's drawing on pages 48-49). This meant that we had to find a place to park the truck where I could shoot from far enough below it to get sky between the wheels. Also, it had to be aligned with the road so that I would be shooting either to the east or west (to catch either a sunrise or a sunset). Obviously, heavy traffic on the road would also preclude its use. The location we settled on was a very high-built, curved road with low traffic flow that led to a nuclear power plant. I knew the road because I had been out to the plant to shoot a calender for them. They gave me permission to shoot, provid-ed we schedule the session between shifts. Since sunset was around 7 p.m. this worked out fine.

• **Finding the Truck.** The shot also called for a truck with doors that opened to the side. Trucks are not normally built this way, and as it turned out, the only trucks that have side-opening doors are ones used by moving companies. Because the truck needed to be silhouetted, we picked a truck with a black cab. The white trailer also had to be made black, so we taped seamless black paper over the entire side of it.

• **Exposure.** The photo was made with a 4"x5" view camera using a double exposure. The first exposure was of the truck silhouetted against the sun. The second round of exposures was made about an hour later. The open door of the truck was covered with white trans lum. The film was then run back through the camera and, as strobes flashed inside the truck, a second exposure was made using a fog filter over the lens.

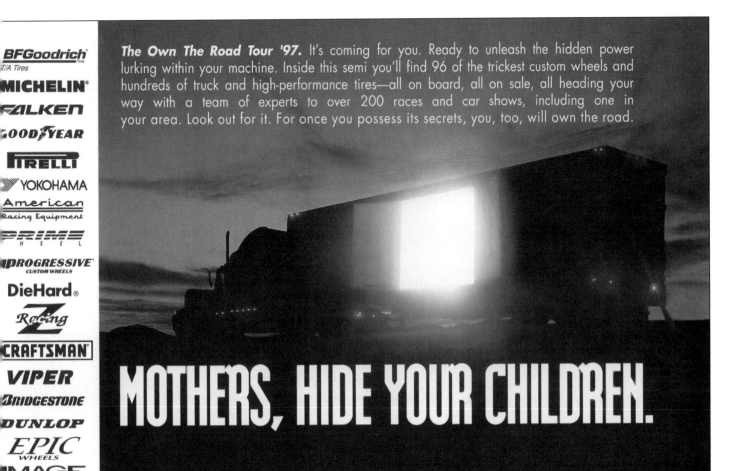

The Own The Road Tour '97. It's coming for you. Ready to unleash the hidden power lurking within your machine. Inside this semi you'll find 96 of the trickest custom wheels and hundreds of truck and high-performance tires—all on board, all on sale, all heading your way with a team of experts to over 200 races and car shows, including one in your area. Look out for it. For once you possess its secrets, you, too, will own the road.

MOTHERS, HIDE YOUR CHILDREN.

Coming to all Lowrider
events on page

NTB
NATIONAL TIRE & BATTERY

SEARS
Auto Center

© 1997 Sears, Roebuck and Co.

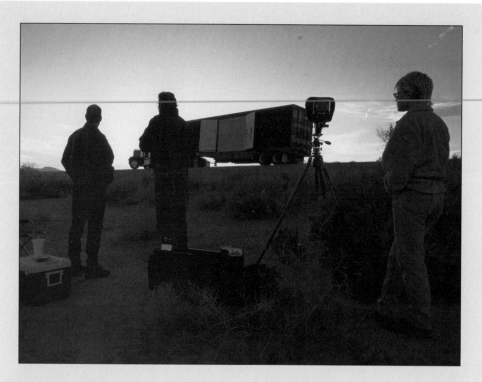

Production

Once you have the job, getting the photographs can still be a challenge. To the right is shown the artist's concept of the ad (the final version is shown on the previous page). As described on page 46, meeting the specifications of this image required quite a bit of work. The picture above was taken on the shoot, as the sun was beginning to set.

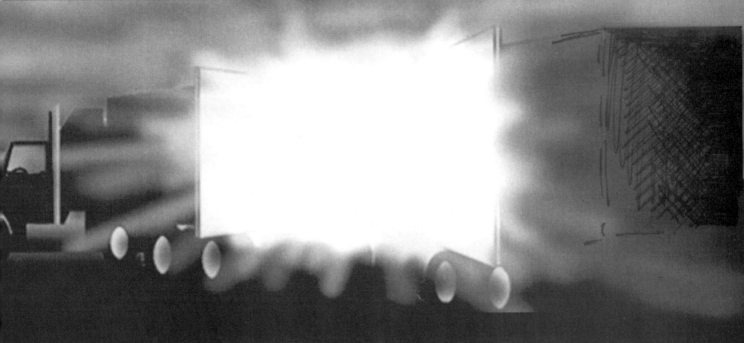

MOTHERS, HIDE YOUR CHILDREN.

It arrives under cover of darkness, ready to unleash the hidden power lurking within. It can make even the mildest of men and machines own the road. Inside this semi you'll find 96 of the trickest custom wheels and hundreds of high performance tires - all on board, all on sale, all heading your way with a team of experts to over 200 events nationwide. Look out for it. Because once you possess its secrets, you, too, will own the road. *Own The Road in '97.*

NTB
NATIONAL TIRE & BATTERY

SEARS
Auto Center

This shot came as a consequence of another session. I was in the studio doing a test shoot with a model I knew, and she brought her boyfriend along. He was a big guy, and she wanted to do some pictures with him. He had a particular pose in mind, so I told him we'd try it. As soon as I saw him strike this pose, I knew it would look incredible on film, especially lit from the top. I shot it for an hour, working in both black & white and color.

• **Stock Sales.** After the session, the shot sat around for a year or two. Then we were contacted by an agency that wanted to use it for their logo. They went through four months of development on the project, but it eventually died in production. Later, I was able to sell it for use as a logo in Italy, and that one hour, spontaneous shoot turned into $10,000 for one year use of the image. I have also used the shot in my own promotions.

• **Running a Studio.** My studio is one of the nicest in the area, mainly because I've spent a lot of money making it that way. Remember, perception equals reality, and when people look at my studio I want it to give them a good message about the kind of work they can expect to get out of it.

Since most of my current work is done on location, I've also gotten into studio rental. I run this as a separate business with a separate name, although in the same space. This separation is important because I don't want there to be any confusion about the fact that I am a photographer.

I used to have about eight employees, but I got tired of spending my time being a boss, rather than a photographer. As people left, I eventually stopped replacing them. Now I have a studio manager and maybe an assistant, but the operation is much more streamlined than it has been in the past.

"... that one hour, spontaneous shoot turned into $10,000 ..."

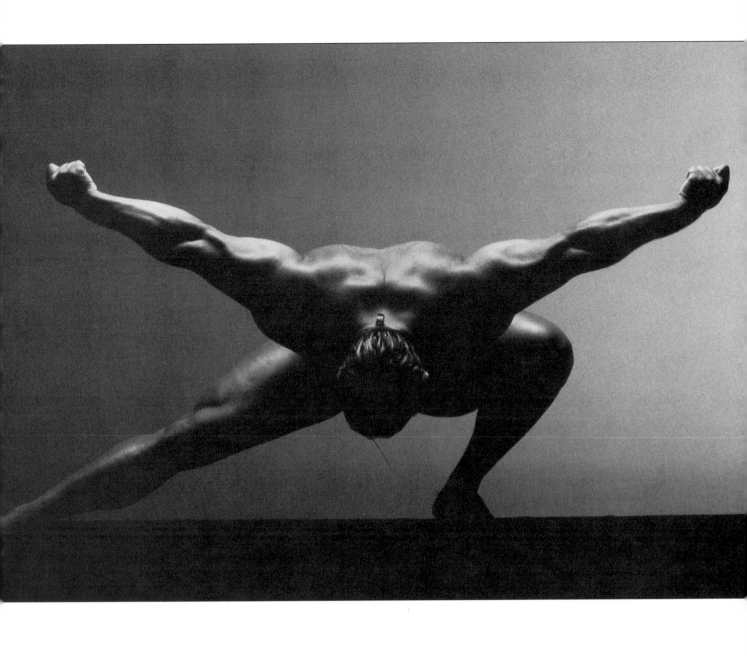

This photograph was taken for a company that was working on tabletop drink menus for Seagram's. They had me shoot the photos for a promotional menu that would be sent out to advertise their product. To get the shot, I played around with different arrangements of three or four bottles. The art director originally wanted a Polaroid transfer image, but since this look is getting a little old, I suggested an emulsion transfer image instead. Books on Polaroid and emulsion transfer techniques are widely available. By using the technique to apply the photographic emulsion to a piece of hard bond white cardboard, I got a stretched and wrinkled effect, as you see below.

"... I suggested an emulsion transfer image instead."

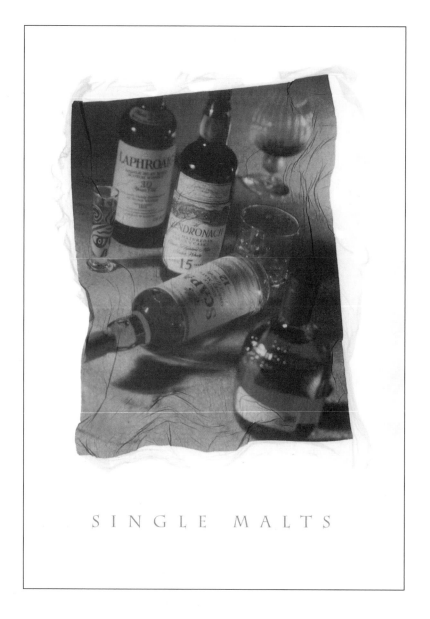

SINGLE MALTS

Using emulsion transfer created an image with the fresh and creative look the client wanted.

When shooting a celebrity, the amount of time you get to spend with the model is generally very short and has to be scheduled to the minute. In this case, we had two hours to do six shots, in six locations of NBA star, Charles Barkley. The images needed were a locker room photo, a shower shot, images in the gym, a shot standing up, an image with Charles seated on a bench, and a photo of him making a basket. This meant that good planning was essential (especially in the shot on the opposite page).

• **On Location.** Part of the planning for the shoot involved location scouting, since we needed an old style gym for the shot. We ended up working in a high school gymnasium, and got there early with four sets of equipment. Every shot was pre-lit, and all of the cameras were set up using other models.

The location itself suggested an additional image that I wanted to get. The gym had south facing windows. I knew the time of the shoot, and knew that at the end of it, at about 4 p.m., a shaft of light would be coming in through those windows. So, while doing the set up for the other shots, I also put in place a smoke machine. By the time we had the six images the art director needed, our time was completely out, and Charles was due in another location. Still, I was able to convince his escorts to let me shoot for about another 30 seconds with Charles in the beam of light. I sat on the floor, set the camera on auto, and was able to get off about half a roll before they took him off to his next appointment. As it turned out, this was the best-liked shot of the session!

To see how we executed the photograph of Charles shooting a basket, turn to page 60.

"In this case, we had two hours to do six shots, in six locations."

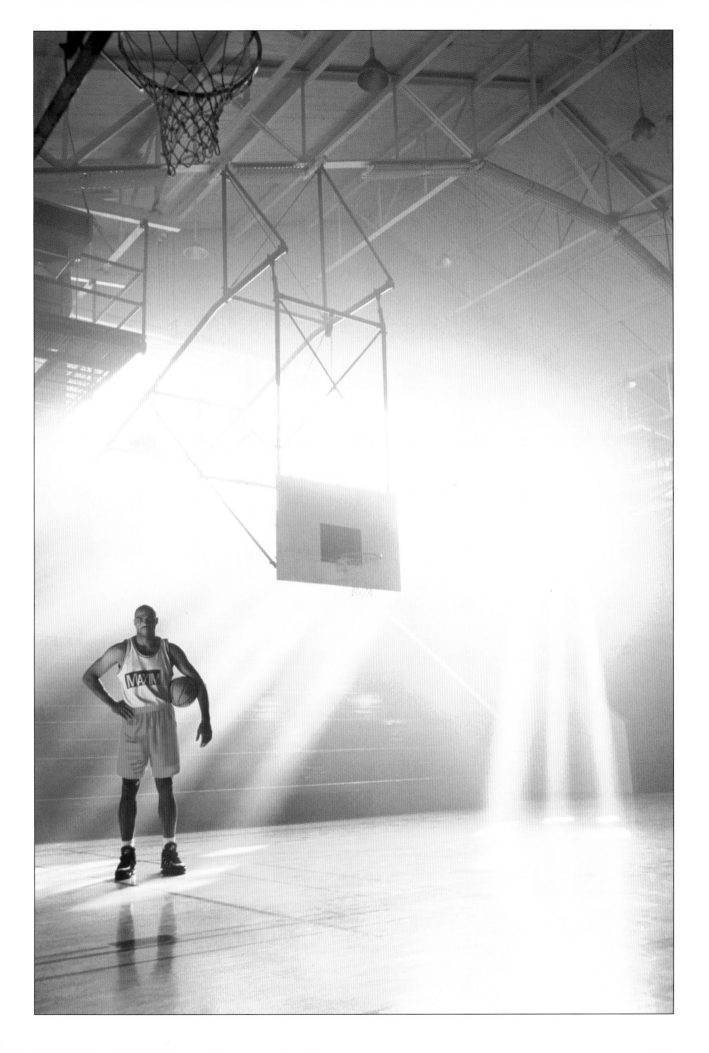

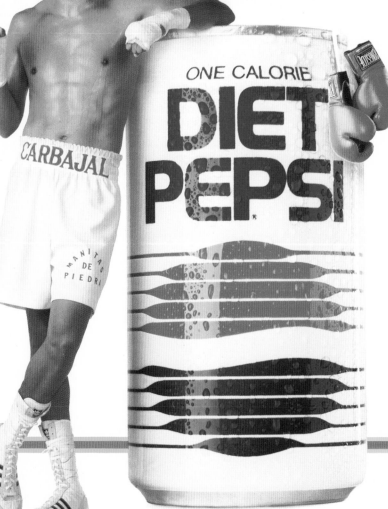

LOS CAMPEONES

THE CHAMPS

Campeón Mundial Mini-Mosca IBF

"The Spanish language market for advertising photography is getting very big ..."

The Spanish language market for advertising photography is getting very big, and I am getting more and more business from it. The model for this ad was a world champion boxer, and the campaign was for use on busboards. To take the three shots, Pepsi sent in a perfect mylar can that was pre-approved by their marketing department.

The can, the subject and the gloves all had to be carefully lit to make sure that the lighting was identical and would match up perfectly when the shots were digitally combined. To create an accurate shadow on the can, a cut-out matching the boxer's pose was used.

• **Shooting Celebrities.** The number of people you can expect to have on a shoot depends a lot on the subject matter. If it's a boring shoot, there will be very few. If the shoot involves a celebrity model, people who want to be there will come out of the woodwork! In this case, you'll want to try to limit the number of people who are present. A big crowd can make the shoot miserable for the celebrity, and that's not the way you want sessions with you to be remembered.

• **On the Set.** Typically, a shoot involves myself, my assistant and the art director. Additional people on site may include make-up, hair and wardrobe people, and occasionally the account executive. The shoot is my responsibility, and if something goes wrong, I will be blamed. I answer to the art director, but sometimes even the art director needs to be made aware of problems like time constraints and rapidly fading light. You must let the art director know when any immediate decision is necessary in order to complete the shoot that day. Remember, you have to prove you can deliver the product, but you also have to give the art director a pleasant experience if you want to work with him in the future.

Shooting from atop a ladder and using natural light, I achieved a natural feel for this photo taken for a local condo complex.

• **Local Clients.** When doing advertising photography, you generally work with clients whose budgets range broadly (from a few hundred to tens of thousands of dollars). I find that the bigger the client, the less hassle the shoot will be. A $200 job that seems quick and easy at the outset, can turn into a nightmare simply because it is just so important to the client. The "simple" shoot may turn into an all day affair, the client may be extremely nit-picky and worried about the results. Their lack of knowledge of what it takes to complete the photo can add hours and dollars to the project – costs that they have not always budgeted for. In contrast, big clients tend to know what the deal is. They are more professional and they know what to expect. The shoots tend to be more fun, and you are usually treated better on them.

This certainly does not mean that you should ignore opportunities to work for small clients – remember that these companies will often grow, and you can grow with them if they like your results. Small accounts can, over time, turn into big ones. What this caveat does mean is that when working with clients who have little experience with advertising photography, you should expect to spend a lot of time instructing them. Clients often don't know what they need – you may have to explain the difference between a color negative and a 4"x5" transparency and for what applications they would want to choose one or the other. You'll need to be straightforward and give your client some basic training. Be sure to take nothing for granted. I walk them through everything step-by-step. For instance, if a client needs a shot of sheets on a bed, I will explain to them that the more they do to prepare for the shoot, the less they will have to pay me. For instance, if I have to iron the sheets and rent the bed, it will cost more than if they do it themselves.

"... often these companies will grow, and you can grow with them ..."

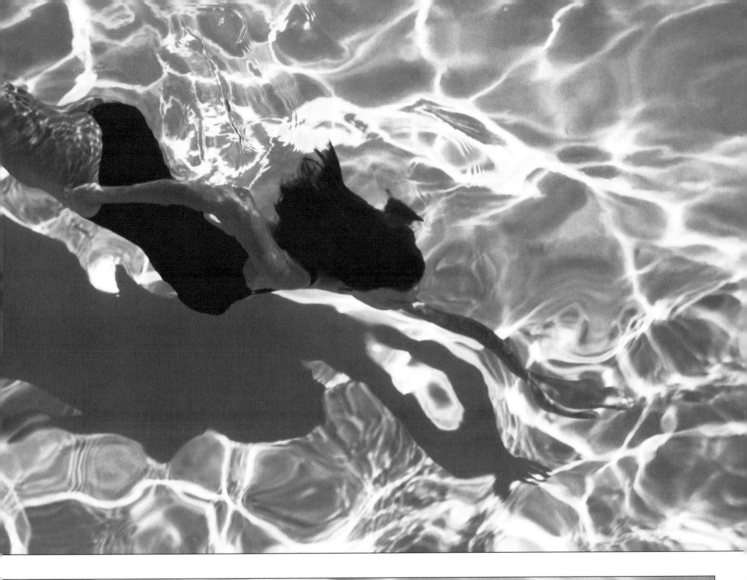

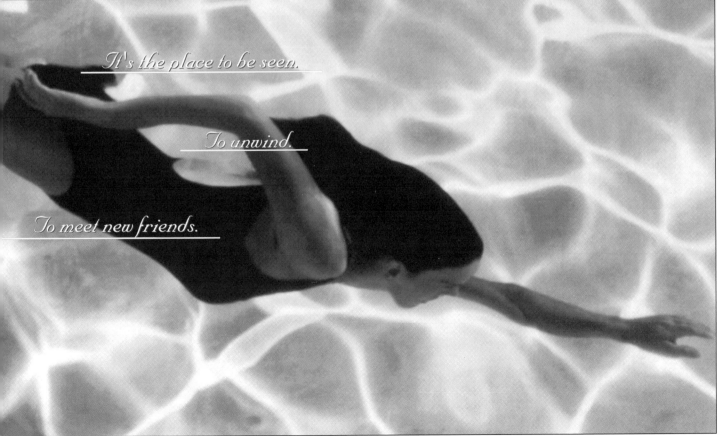

It's the place to be seen.

To unwind.

To meet new friends.

This was a shot of a new model of boat taken for a company in Arizona. To get the image I shot from a helicopter, using a shutter speed that would blur the water. I used about 30-40 rolls of film. It's a good idea not to skimp on film when shooting motion. This is true whether you are photographing objects or people. What's important is that you get a usable image for the client.

• **Submitting the Images.** When submitting your images to the art director on the project, you should, of course, remove any images that have no possible use – anything underexposed or really out of focus, for instance. Sometimes the art director and I will shoot an additional angle that we realize may not fly. This not only gives the client multiple choices, but also allows that art director to sell the favored image against the secondary image. Ideally, when they look at your images, they will look at that secondary photo and say, "Well that one's out – but I love this one!"

"What's important is that you get a usable image for the client."

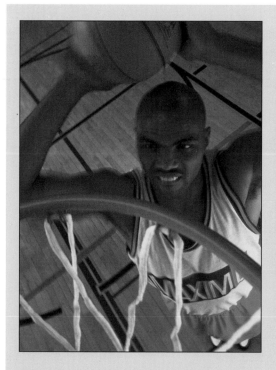 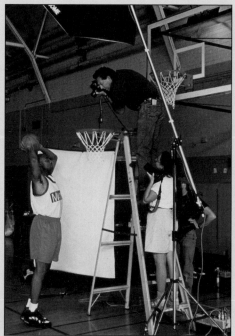

Creating the Illusion

Remember, the camera is totally objective, but it's your job as the photographer to use it to capture images that convey a subjective message. Here, the shoot may not look too inspiring, but by incorporating movement and a unique perspective, the resulting image is full of motion and excitement.

MAN OVERBOARD! Quick ... Seize The Situation!

Boating World

February 1996

EXCLUSIVE

JET
OWER
UYER'S GUIDE
5 for '96
Watercraft Reviews

JETTING OFF ON ADVENTURE

T VS. PROP
wer Pros & Cons

$2.95 US
$3.95 Canadian

02 >

0 71486 01311 2

When I got this assignment, the skyline had already been picked out, so I shot the couple and the car in my studio. The two photos were later combined to create the final image for the ad. If you look carefully at the windows of the car, you can see one little error (a window through which you should be able to see the skyline, but can't).

In order to make the lighting of the image match the skyline, I lit the scene in tones that matched the color of the sky. To get the reflection of the skyline in the hood of the car, I used a black foam core board cut to match the shape of the skyline. Lighting a highly reflective surface can be difficult (here, especially difficult because of the curved surfaces involved). The key is not to light the car itself, but to light what is reflecting into the car. Additionally, you must be sure to hide all the light stands and lights so that they are not visible as reflections on the car.

• **Tear Sheets.** Getting tear sheets (copies of the final published ads) from clients can require a little begging, but are nice to have around. When using images from a prior assignment in my portfolio, though, I always use the original image. Remember, you are submitting your work to people who are very conscious of design and layout, etc. If you submit a photo with the text in place on it, the ad director may look at and judge the ad rather than simply your photograph. You also don't need to include a resume with your portfolio – your portfolio *is* your resume.

Big client names definitely add credibility to your image, but you may be better off discreetly dropping these in conversation rather than including them in your portfolio. You should start doing this, always subtly, from the first time you speak to a potential client.

"Lighting a highly reflective surface can be difficult ..."

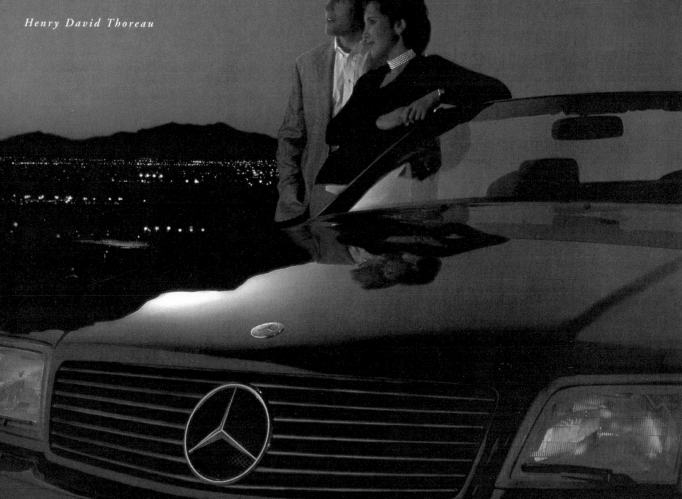

"If one advances
confidently in the direction
of his dreams, and endeavors
to live the life which he has
imagined, he will meet
with a success unexpected
in common hours."

Henry David Thoreau

PHOENIX MOTOR COMPANY

Despite what some people may think, digital imaging is not necessarily altogether threatening to photographers, as my experience with Winnebago will demonstrate.

• **Digital Imaging.** Winnebago decided a few years ago to try using digitally composited photographs in their brochures that show motor homes in various natural scenes. The motivating factor was cost. To shoot the vehicles on location would have involved driving thousands of miles (from Iowa, where they are manufactured, to across the western United States where the shoots were planned). This would mean paying drivers and crews for their time, food and hotels. It would also mean rendering worthless five expensive motor homes.

Instead of incurring these expenses, the company had me shoot the locations. Then, with care to duplicate the light, camera height and lenses, they shot photos of the motor homes back in Iowa. My fee for the shoot was exactly the same as it would have been with the motor homes on location, and the company saved an enormous amount of money in production costs. Because each ad costs less to produce, this may also encourage the company to do more ads (and use my services more).

"The motivating factor was cost."

On the Shoot

Selling your work doesn't end when you get the assignment. You also need to sell your work while you're on the shoot. Telling your client that the images you're getting are great predisposes them to see the photos as great when they arrive in their office. Clients can find faults in everything – and if you exhibit a lack of confidence on the shoot, you may convince them that they need to look for faults.

Remember, every photographer out there knows how to do the big things, but it's doing the little things that help make you a success and keep you in business. At every step of the process, you need to ensure that the details are handled. Make sure to learn the name of your client's secretary, send thank-you notes, make sure that working with you is a great experience.

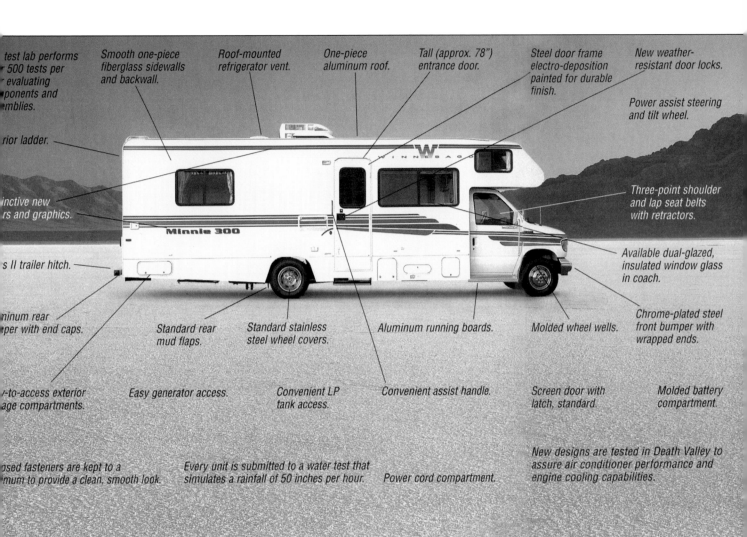

test lab performs
500 tests per
evaluating
ponents and
mblies.

Smooth one-piece
fiberglass sidewalls
and backwall.

Roof-mounted
refrigerator vent.

One-piece
aluminum roof.

Tall (approx. 78")
entrance door.

Steel door frame
electro-deposition
painted for durable
finish.

New weather-
resistant door locks.

rior ladder.

Power assist steering
and tilt wheel.

inctive new
rs and graphics.

Three-point shoulder
and lap seat belts
with retractors.

Minnie 300

Available dual-glazed,
insulated window glass
in coach.

s II trailer hitch.

ninum rear
per with end caps.

Standard rear
mud flaps.

Standard stainless
steel wheel covers.

Aluminum running boards.

Molded wheel wells.

Chrome-plated steel
front bumper with
wrapped ends.

-to-access exterior
age compartments.

Easy generator access.

Convenient LP
tank access.

Convenient assist handle.

Screen door with
latch, standard.

Molded battery
compartment.

osed fasteners are kept to a
mum to provide a clean, smooth look.

Every unit is submitted to a water test that
simulates a rainfall of 50 inches per hour.

Power cord compartment.

New designs are tested in Death Valley to
assure air conditioner performance and
engine cooling capabilities.

Winnebago Adventurer

Despite what some people may think, digital imaging is not necessarily altogether threat-ening to photographers. To read more on how digital imaging was used in this job, turn to page 64.

This image is part of a project I've undertaken to try to reinvent my style and make it more current. The project was sparked by a visit to my New York rep who took me around to several art buyers to have them evaluate my portfolio. Their comments were all the same – my images were technically perfect, with strong color, layout and design, but needed more emotion. They wanted to see images that say a word to the viewer, like "jealousy" or "love" or "hate."

This turned out to be harder than I thought, and I've been working on it for three years. My goals have been to shoot with more natural light, to create images that are less polished, and to try to get models to really give me a lot of energy and attitude. As in this image, I'm trying to capture more energy and show a mood, rather than a slick and technically perfect image.

• **Expanding Your Vision.** I've needed to push my parameters to accomplish this adjustment of my style. I think we all have a sort of box in which we operate. Some people can just naturally operate outside of this box – these are the extremely creative people who do the most cutting edge work. There is certainly a market for this in advertising photography, but it's only about 5% of the total marketplace. Also, this work, while extremely hip and profitable for a while, tends to burn out quickly. For the rest of us, who are a little too mainstream to just hop outside the box, the way to expand our parameters is to make the box bigger. That way if we can get out even halfway to the edge, we are doing pretty well. How do we expand the box? My answer has been to consciously expose myself to every kind of art – the more bizarre the better. This gives me a lot of perspective and has helped me to look at my work from a different angle.

"They wanted to see images that say a word to the viewer, like 'jealousy' or 'love' or 'hate.' "

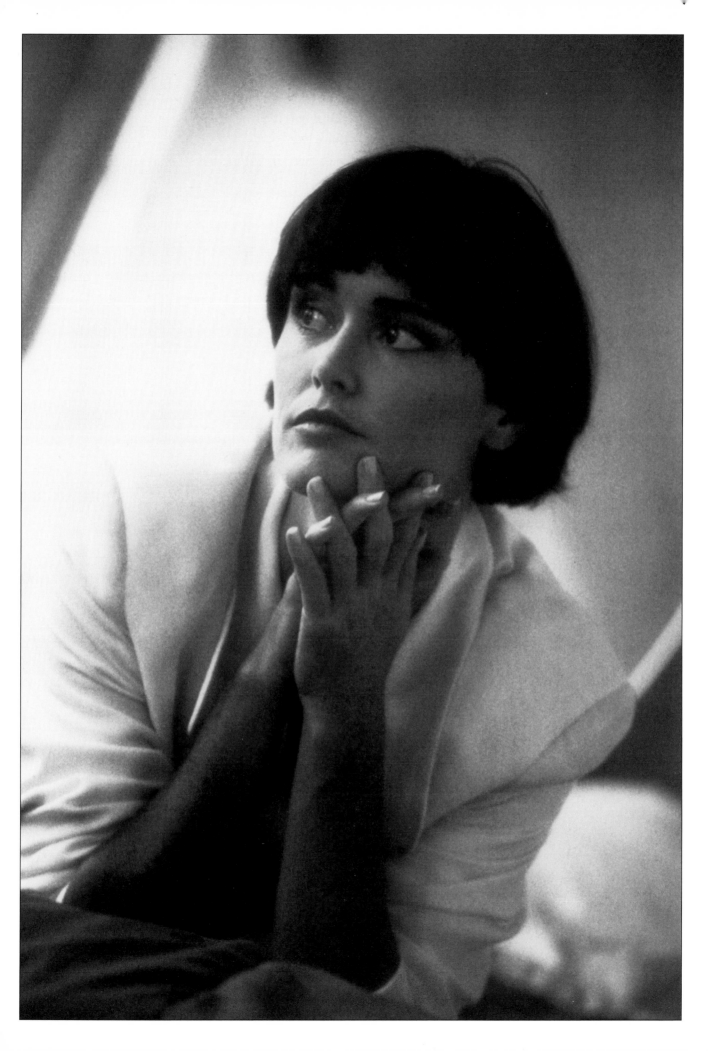

Lockheed-Martin was going after management of the multi-billion dollar space shuttle account. They wanted to replicate the look of Mars in an ad for engineers. Since the target audience would know what Mars looked like, the scene had to be accurate.

• **Preparing for the Shoot.** To prepare for the shoot, we got scenes of Mars from NASA. The hills were rounded, there was no vegetation and the sky looked pinkish, like an earth sunrise or sunset. The best area to duplicate this look was in the Valley of Fire, Nevada. Even here, to create a truly authentic look, we had to digitally round off the rocks, pull some dead vegetation and smooth out the clay. We also had to rent a spacesuit (for $1500), and send out someone to take a day's worth of lessons on its use.

After securing a permit, we shot for two and a half days at four different locations, using natural light.

"They wanted to replicate the look of Mars ..."

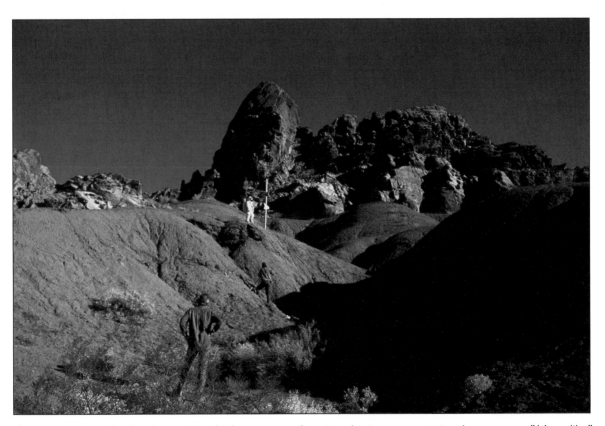

As you can see, the landscape in which we were shooting the image contained many non-"Mars-like" features which had to be dealt with to make the images look realistic.

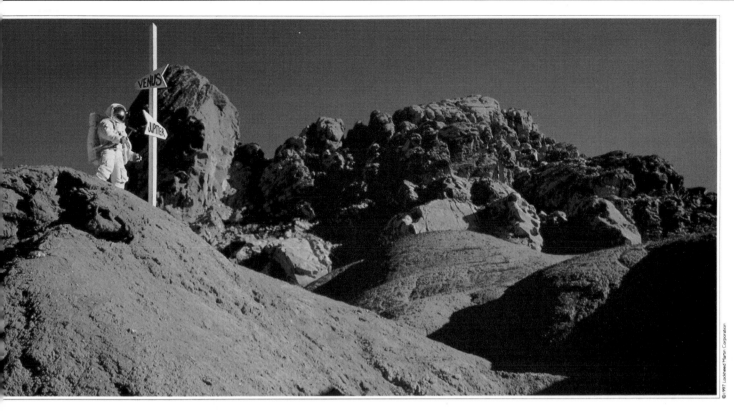

v far do you want to go?

It's not a destination. It's more like America's destiny. And NASA is leading the way.
Our Consolidated Space Operations Contract team will play a vital role every step of the way. With our
unmatched space operations experience and expertise, we will help NASA realize significant reductions in
operating expenses. Letting NASA focus on what it does best: explore the heavens.

This photograph was shot during a test shoot with a model who eventually ended up working with me as a photographic assistant.

I was doing the test shoot in preparation for an upcoming product catalog for Coors. The company didn't want to use professional models, but was instead looking for "real people." As it happened, the model you see here walked in to inquire about working as an assistant. She had the look the company wanted, so I ended up using her as a model and eventually as my assistant.

"... location shouldn't necessarily be a deciding factor in the kind of accounts you go after..."

• **Locating Your Studio.** Even if you aren't willing to move to New York or Los Angeles, location shouldn't necessarily be a deciding factor in the kind of accounts you go after and receive. As we have entered the electronic age, location has come to matter less and less. It's fair to say there really isn't such a thing as a "local market" anymore.

• **Promoting Your Studio.** What matters more than location is the image you create for yourself and your work. Your promotions are an integral part of creating that image. For example, when I was establishing myself, I wanted my studio to have a young, hip image. To make this impression, one of the best promotions I ever did was to host a huge Halloween party in the studio. These parties, called "Tall Paul's Pumpkin Ball," involved six hundred guests (with many big names among them), bands, laser shows, fog machines, special lighting and huge amounts of preparation. Although I don't give the parties anymore (because of the legal considerations involved with the possibility of sending hundreds of people home drunk), they really helped impress upon people what my studio was all about. To this day, people still ask me about the parties.

Ishot this photo as part of a test shoot on a mountaintop. I chose this hurdling pose because I was trying to get a very sporty look in the image. It always pays to try a lot of variations.

Although it was part of a test shoot, I'll still use it for stock photography, as well as in my portfolio. Remember, your portfolio should be customized for every job – for instance, fashion, cars, food, architecture, etc. Your portfolio should always be evolving to show current subjects and styles. Images from test shoots can help give you more choices when putting one together.

"... I was trying to get a very sporty look in the image."

Location Scouting

When you're looking for the perfect spot for a shoot – whether it's a lighthouse, a waterfall or the perfect mountaintop – a location scout can provide a great deal of help. Some location scouts are locally based, some regional, national or international. If it's out there, they can help you find it. In addition to finding the spot, a location scout will provide you with the other information you need to schedule the shoot, such as sunset and sunrise times, availability of parking, what kind of crowds the spot draws, etc. Shots from a location book (such as pictured to the left), will help you decide if a particular site is the one you want to use.

The shoot for this image took place in Las Vegas and was commissioned by the airline. We did the image at about eleven in the evening, and had the plane pulled up to the end of the runway for the shoot.

There were a total of five people on the shoot – myself and four assistants to help with lighting. I was positioned on top of a generator truck and used a telephoto to get the shot.

Lighting an object as large as a plane is a fairly involved process. My assistants were positioned around the plane with strobes. I shot lots of test Polaroids and communicated with them via walkie-talkies as we fine tuned the lighting. When the lighting setup was done, the flashes were popped and the lens left open.

•**Snip Tests.** I hate snip or clip tests – the process of cutting off a frame or two from each roll to determine if it has been correctly exposed. Inevitably the lab will cut through a frame you wish you could keep. To avoid this, whenever possible we shoot test rolls on a separate back that is labeled "Test." On each different light set-up we shoot a three exposure bracket. (normal, half stop under, half stop over). This test roll is then processed first, and the bracket gives us an idea of whether we need to push or pull the film (or process it normally) to achieve the desired exposure. On all distinct lighting situations, we label all the rolls sequentially, no matter how many we shoot. We also try to attach a corresponding Polaroid for further identification.

• **Processing.** On hard to re-shoot or difficult shoots, never process all your film in one run. In the rare circumstance that something goes wrong at the lab during processing, it can be a life saver to have half your film left for another run. I learned this lesson the hard way when, early in my career, a lab destroyed four days worth of shooting by processing my E-6 as C-41. I not only lost a very profitable assignment fee, but also an account that had been very profitable. Remember, if you screw up, it's not just the single job that's at stake, but the whole account and all the future business it may generate.

> "Lighting an object as large as a plane is a fairly involved process."

Running a roll of test film on a separate back can help you determine whether to push or pull your film.

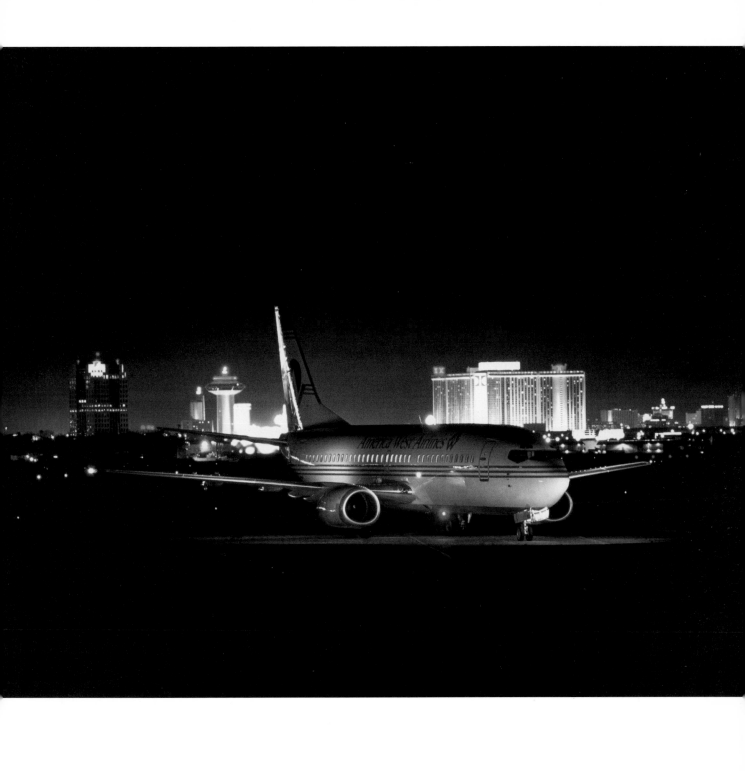

As a test I took some images of Miss Fitness Arizona. We did some images for her use, but also did some images for my use.

"Since taking the image, I have sold it as a stock photograph."

• **Concept**. I had an image in mind of a dancer jumping out of the frame. Since this model had a great athletic body, it seemed like a good opportunity to try the shot. The image I wanted was one that was low on convention, but high on movement and emotion.

To achieve this emotion and sense of movement, I used a tungsten light to illuminate the dancer from behind. The flash of a strobe freezes her action, then the shutter was left open for 1/8 second after the flash.

• **Sales.** Since taking the image, I have sold it as a stock photograph. One sale was to a design group who used it in a poster they sent to local designers. Sales like this are great for my business, since the image is always used with my name on it. Here, the poster was a great way to splash my name to agencies from whom I might later get jobs.

A Practical Tip

Packing for an assignment is a continuous process of downsizing. Gaffer's tape is one of those indispensible items you should never leave home without. Still, carrying three rolls of tape (black, white and grey) not only takes up space, but also adds weight. For many small assignments, I have found that re-rolling tape onto my tripod legs not only saves space and weight, but guarantees the tape will always be close at hand in those emergency situations.

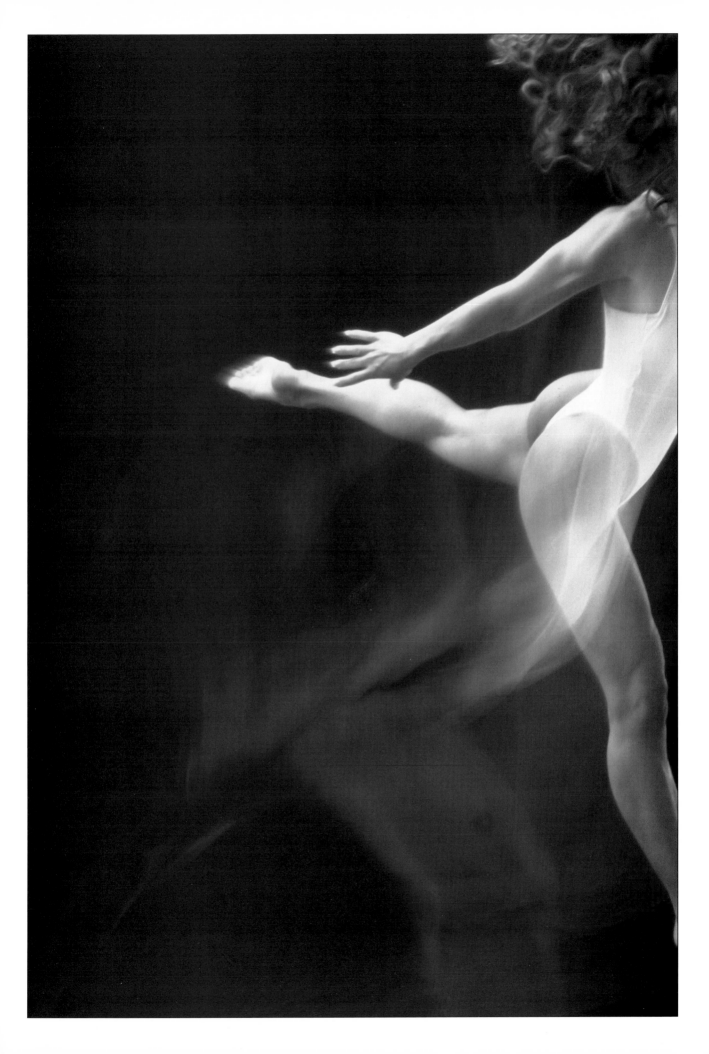

This photograph was taken with the first female driver of a 250-ton truck which is used exclusively on the grounds of a mining company since it is so massive it would destroy normal roads and bridges.

• **The Concept.** The concept behind the image was to show the contrast between the gigantic, heavy truck and the diminutive size of the woman in comparison, and also to show a woman doing what is usually thought of as a man's job. Remember, in terms of design, the old tricks still work. Sometimes you may choose to work with something fresh and new (such as the image on the previous page), but you should never forget the impact that classic contrasts (small with big, dark with light, hard with soft, etc.) can have in an image. These are always safe compositional and design principles to fall back on.

•**The Shoot.** The photograph was shot with a telephoto lens from about a quarter mile away, with the subjects posed at the edge of an open pit mine. We did the shoot at sunset, exposing the image for the sky and using additional strobe lighting.

"These are always safe compositional and design principles to fall back on."

Keeping Subjects Straight

I have always envied those gifted with wonderful memories. On any given assignment I can be shooting any number of people in front of my camera. "Hey you — move to the left!" is not always the best way to address an important subject. In order to keep the names and and faces straight, my assistants always try to get the names of the subjects, write them in big letters on gaffer's tape and discreetly place this label for my eyes only on the back of the camera.

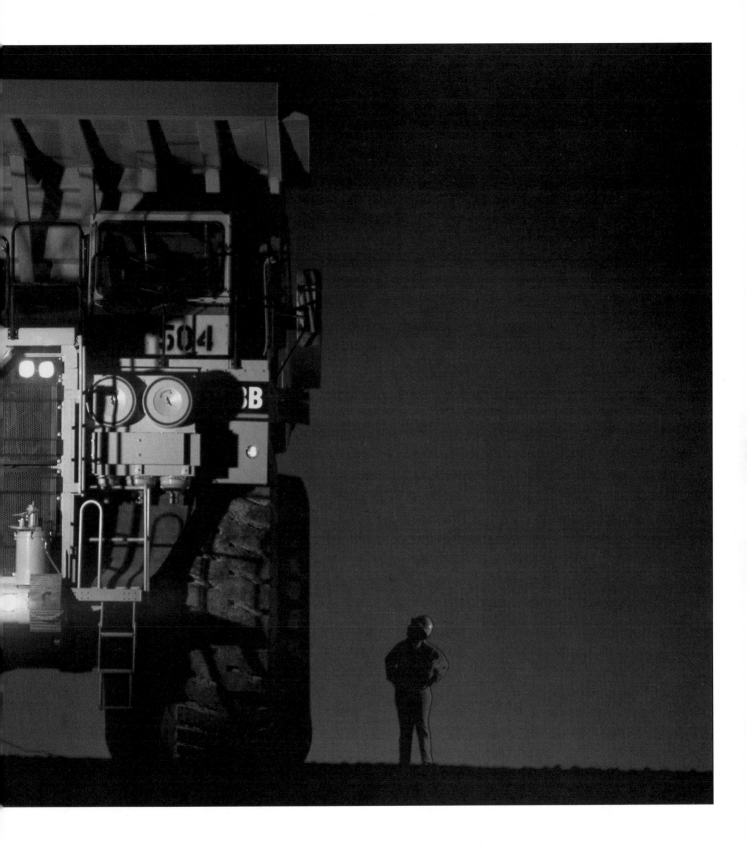

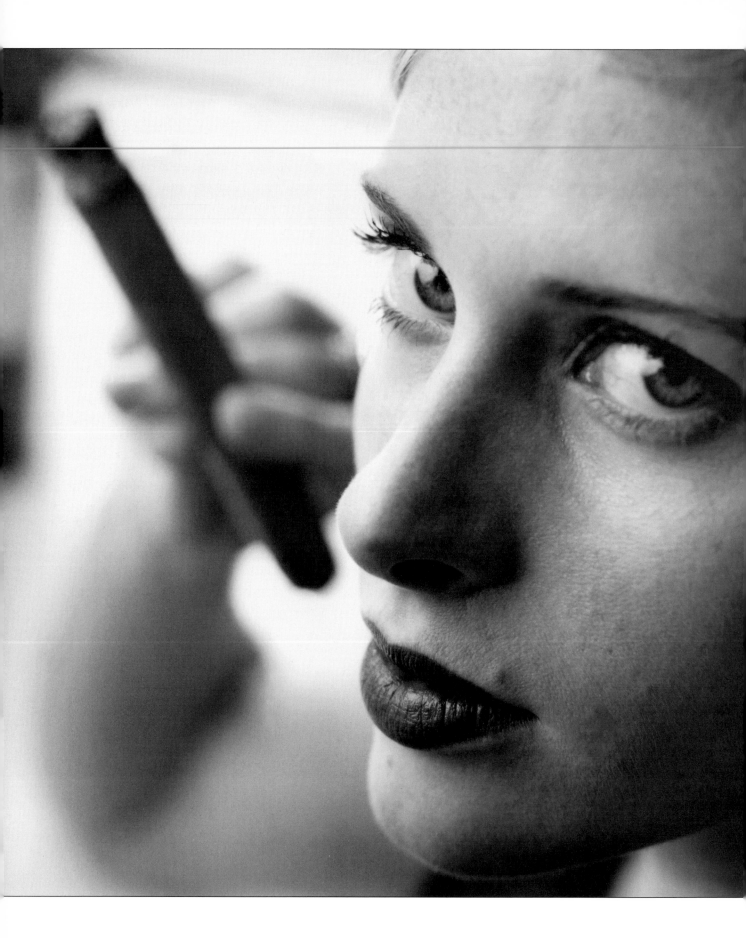

"... the unique angle of the camera ... is part of creating this energy."

This ad for a restaurant was a fun account to work on. Basically, I came in and played around until we got the right shot! The ad was to promote a cigar night at the restaurant, and was sent out on a 5"x7" post card. My goal was to create an image that wasn't totally slick or technically perfect, but had a lot of mood. You'll notice especially the unique angle of the camera, which is part of creating this energy. The cigar doesn't even register immediately as a cigar. That's not necessarily what you expect in an advertising image, but since the text would announce the nature of the event, the photograph could concentrate on setting a fun and inviting mood.

• **Working with Clients.** When working with local clients, expect to spend some time helping them figure out what they need. You may also want to make yourself familiar with the services offered by printing companies in your area, as well as their costs. This can be very helpful in discussing with a client what they need in terms of photographs.

Something you'll need to explain to most small clients is that buying photography is like buying a car. You can buy a compact car or a sports car or a luxury car, and all of them will get you there, but they will also say something about how you are perceived when you arrive. There is a market for all levels of cars, and a market for all levels of photography. Clients need to think about what they want to say, and what they can afford. Often, you will find that client's needs will evolve with their business. For instance, a new hotel with no money to throw around might have you shoot images for a flyer when the building isn't even quite done and you have to work around construction. Later, they may work up to some nicer shots, using the employees as models, but still with a very small budget. Three years down the line, though, don't be surprised if they call you wanting really top-notch images, with professional models.

The very talented model for this photo is quite literally a man of a thousand faces. After casting him for the shot and outfitting him with a wig, I told him to look shocked, and this is what I got.

I shot the image with a wide angle lens, using Polaroids along the way. These are not only a great help with the technical aspects of the shoot, such as composition and lighting, but can also be very helpful in showing the client how things are going. Additionally, they can be instrumental when working with a model to get him to give you the look you need.

• **Working with Models.** When you're working with a good model, such as this one, you shouldn't need to give him or her a great deal of instruction. This doesn't mean you should expect the model to walk in cold and give you what you need. Rather, take the time to show your model the layouts of the image, let him know what you need, and talk to him about the expression or mood you are looking for. Again, reviewing Polaroids as the shoot progresses can also be of great help. A good model should be part of the creative process, working with you to make the best image possible. If I find myself working on a shoot where the model needs a lot of help, I know I'm in trouble!

"I told him to look shocked, and this is what I got."

Business portraits can often be pretty dry, but this photograph of an executive with a phone manufacturing company is anything but.

• **Concept.** The company used this photograph in their annual report. The concept behind the photograph (one of a series of three images), was to feature three executives, each holding a part of the company's logo – a green orb, a purple square and a blue triangle. Each object represented a dimension of the company's technology.

• **Photography.** The first step in getting the shot was to have props made for the circle, square and triangle. Each was covered with metallic paint and strung up with fishing line. Then each shape was lit with the proper color of light – green, purple and blue.

Next, to create nice shadows on the background, we strung up lines and rods. The background was then illuminated with tungsten lighting.

The final component of the image was dragging the shutter and using slight camera movement. The subject was lit strongly with a flash which freezes him in focus in the frame. The shutter remained open after the flash pop, and was then moved slightly. The movement allowed the continuous lighting used on the background to burn in and blur slightly. Since the orb was also lit in the same way, it took on a nice glow.

Dragging the shutter this way (also called creating a wraparound exposure) is a great way to give a little edge to a photo. It is particularly nice in a business portrait since it allows you to create an image that is basically mainstream, but still a bit catchy.

"Dragging the shutter... is a great way to give a little edge to a photo."

A print collateral campaign is a common type of job in the advertising photography business. What it means is that a company produces a television commercial and then uses images from the commercial shoot to run in their print ads. Remember, if you get a job like this, that video and motion picture lighting is much harsher than the lighting for still photography. This means you can't actually shoot your images during the commercial shoot, but will basically have to set up a separate shoot with separate lighting. In this case, when the crew was done shooting for the commercial, I took over and did the images for the print ad.

• **Seasonal Locations.** This photograph was shot in Phoenix, although the company that commissioned it was from the east coast. The reason for shooting here was that it was December, but they wanted the look of a nice fall afternoon. It's not unusual for clients to work on location in order to get a seasonal look they can't find in their area at the time. The shoot took place at a house which had been rented for the day and had a very east coast look to it.

"... motion picture lighting is much harsher than the lighting for still photography."

A print collateral campaign involves the coordination of images in the video and print advertising. Generally this means taking your photographs at the shoot for the television commercial.

90

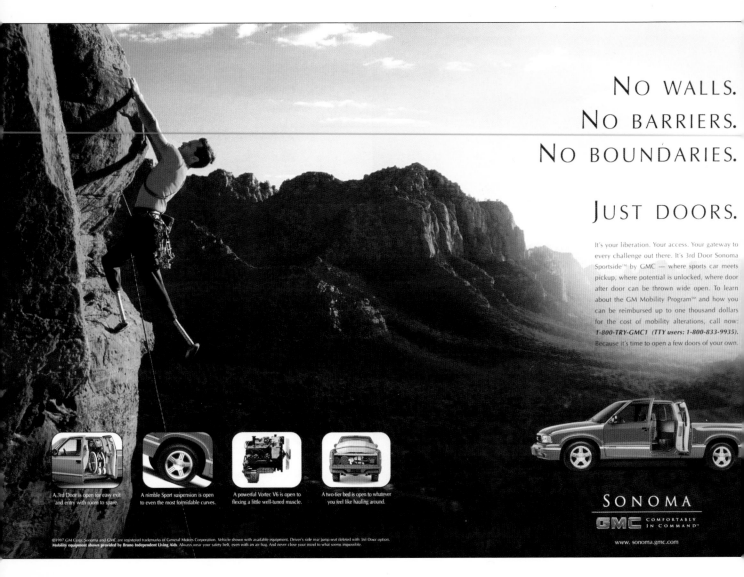

NO WALLS.
NO BARRIERS.
NO BOUNDARIES.

JUST DOORS.

It's your liberation. Your access. Your gateway to every challenge out there. It's 3rd Door Sonoma Sportside™ by GMC — where sports car meets pickup, where potential is unlocked, where door after door can be thrown wide open. To learn about the GM Mobility Program™ and how you can be reimbursed up to one thousand dollars for the cost of mobility alterations, call now: **1-800-TRY-GMC1 (TTY users: 1-800-833-9935).** Because it's time to open a few doors of your own.

A 3rd Door is open for easy exit and entry with room to spare.

A nimble Sport suspension is open to even the most formidable curves.

A powerful Vortec V6 is open to flexing a little well-tuned muscle.

A two-tier bed is open to whatever you feel like hauling around.

SONOMA

GMC COMFORTABLY IN COMMAND™

www.sonoma.gmc.com

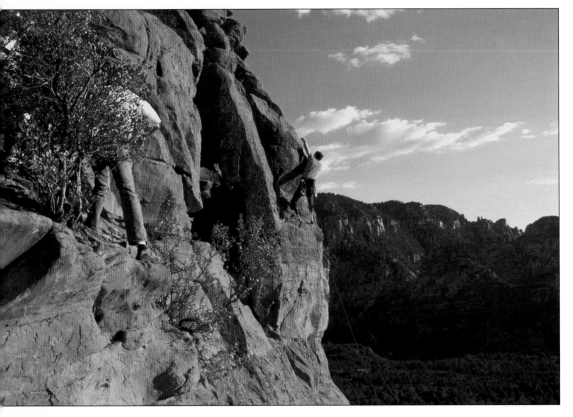

*Location photography
sometimes require you to
a bit of a daredevil. Here,
shoot the climber on
mountain, we had to find
location that was safe
both of us, provided the l
we wanted, and offered
good place from which
shoot. I took the image a
getting harnessed and cli
ing halfway down the cliff.*

"... these little things ... spell the difference between success and failure."

We had to compete hard to get this job. The main challenge was that we needed a climber who used sticks rather than prosthetic legs (which would disguise the fact that he was physically challenged). My studio manager started the search by calling hiking clubs and followed the leads she got until she found this model, who had lost his legs to frostbite in a climbing accident. He was reluctant at first, but after seeing the layout and liking the idea of helping with the promotion of products for the physically challenged, he agreed. The fee was certainly an added incentive – especially since he is a student. Once we found him, we kept his identity quiet, knowing that we had an edge on the competition.

In the end, none of the other bidders could find a model. This in itself presented a problem because the company simply could not get the three bids that corporate policy dictated they obtain. Finally they had to get a special waiver of the policy, and we were awarded the job. Certainly any of the other finalists for the job were qualified, but the simple fact was that we did the work needed to track down the right model. Often it is doing these little things that spell the difference between success and failure.

This job had a high production value and was quite involved. On the shoot were myself, the model, two assistants, climbing experts to rig the ropes, a production person to handle wardrobe, the art director, and the account executive. As you can see on the opposite page, it was sometimes precarious business! The shoot lasted two days.

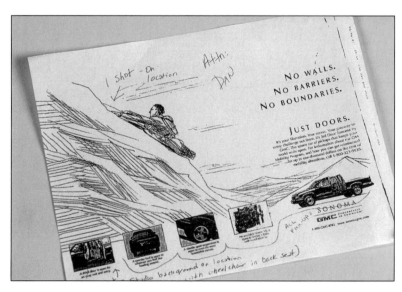

Here you see the artist's sketch for the advertisement. The final version is shown at the top of the opposite page.

I am constantly trying to evolve and update my style. One way to get new ideas and see what other people are doing (and what you can use), is simply to read a lot of magazines. Almost every good photographer I know is a magazine junkie.

"I had the model scream and yell as she bounced on the trampoline."

• **Test Shoots**. Another way to work on your style is to do test shoots, such as this one taken on a mountain top where a trampoline allowed me to shoot the model with nothing but sky behind her. Using the trampoline also creates a lot of possibilities for mid-air posing. Since I wanted to shoot images with a lot of attitude, expression and energy, I had the model scream and yell as she bounced on the trampoline. To shoot, I sat on the edge of the trampoline and used a wide angle lens.

I think test shoots are very important, and almost no one does enough of them. Remember, you don't have to have a big set-up or a professional model to get out there and experiment with some new ideas. Test shoots can be as involved or as simple as you want to make them (for a more involved test shoot, see pages 112-115). If the results are good, you also have more images to add to the catalog of photographs you sell for stock usage.

Film Use
On location I may shoot anywhere from ten to a hundred rolls of film, depending on how much movement and expression is required. Time is also a factor in film usage. On some shoots you may have all the time in world, on others (see for instance pages 45 and 55), scheduling, weather or changing light can effect the number of shots you take.

If your SCALP'S DRY you only need to use your head.

When you put your hair through the wringer—washing, blow drying, styling—your scalp could be thirsting for moisture. The signs? A little itch. Dryness...even flaking.

You've got to use your head. Head & Shoulders Dry Scalp Shampoo.

Its gentle scalp care formula actually works to protect your scalp's natural moisture, while leaving your hair in beautiful condition.

There's no formula like Head & Shoulders Dry Scalp Shampoo.

Head & Shoulders Dry Scalp Dandruff Shampoo

Helps protect your scalp's natural moisture balance.

"... it was $2000 to take a basic head shot ..."

Like the image on pages 90-91, this photograph was taken as part of a print collateral campaign (meaning it was a combined print and television commercial campaign where images from the video shoot were photographed for the print ad). Here, the television commercials featured a photographer explaining to a model that her photos looked great except for her dandruff. He then shows her a picture where the dandruff is very visible on her black sweater. The original commission was to take that shot that he would show her, but ended up including the image for the print ad.

• **Bidding.** Bidding the job was a classic situation. My rep originally put in a bid of $4300 plus expenses, but over the course of two weeks it worked down to $2000 plus expenses. This is on the low side of what would be expected for the job – and I urge you never to take a bid that is *too* low, or you will get the reputation of being a low ball artist. Still, it was $2000 to take a basic head shot, at most a one hour job, so I took it.

The job provides an interesting example of what can happen in a bid situation. One of the competing photographers, a former assistant of mine, called me later and told me that the art director had claimed I underbid him. As it turned out, we had started and finished with precisely the same bid. Apparently the art director had decided to go with me for some reason other than money, but didn't want to hurt the other photographer's feelings. The moral of the story is not to believe you have been underbid for a job just because the art director tells you that's the case. The bid process is always slightly a mystery – you'll win some and lose some. The safest approach is never to count on a job until you have it in hand.

• **Further Usage.** On the set of the shoot, I took the basic head shot they wanted, and considered the job done, until two months later the company called me back and wanted to use my shot for a print ad in *People* magazine. In the end, that single head shot made me $4500.

This image was taken during a film test I did for Eastman Kodak. We had just finished shooting from one viewpoint when I saw this great spot where the light was just starting to happen. It was the end of the day and the shadows were just perfect.

The model had to run about a half mile to get to the rocks on which she is posed. After she had climbed up to the pinnacle. I shot the photo with a 500mm lens.

• **Exhibition and Sales.** The photo appeared in the Kodak tradeshow booth in New York City (with my name on it). I have also sold it as stock to a tourism magazine.

> "... I saw this great spot where the light was just starting to happen."

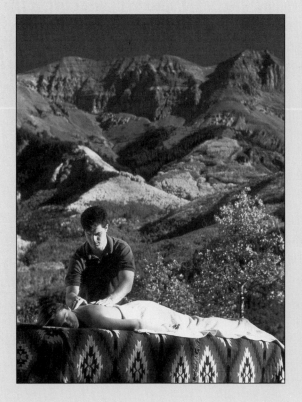

On Location

This photograph was taken for promotional use in a Peaks of Telluride Spa brochure. The first time we went out on the shoot, it rained for five straight days. A decision was made to reschedule, since outdoor images with sunshine were needed. The second time out, a short time later, we able to get all of the images needed for the brochure.

It's not always the nicest people or the best photographers who make it in advertising photography. What it takes to succeed is a combination of preparation, opportunity and luck. You need to know your talents, to be nice, to be on time and be dependable. Part of what I sell my clients is insurance. They know that when they send me out, I will get the shot – no excuses. Remember, art directors want a great shot, but in the worst case scenario, they need to have a usable shot. Never striking out on a shoot is my big selling point.

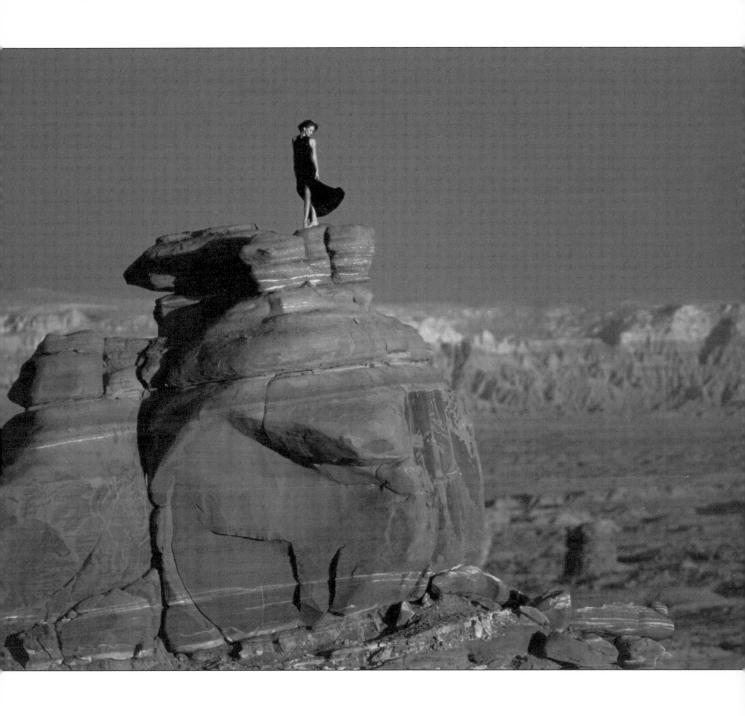

I did four of these posters for the Phoenix Suns Dance team. When I came up with the fire truck idea, I called the local fire department and got the use of a truck for the shoot, on the provision that the city logo was not showing in the photographs. I had also wanted to use fires in the background, but the legal and safety issues were too hard to orchestrate. Instead, a smoke machine was used to develop the mood of the scene.

• **Location.** The photograph was shot in the warehouse district when the sun had barely gone down. To illuminate the entire scene and the dancers took about twenty lights. Setting up the shot took about five hours, while the actual photography took only about an hour.

• **Group Posing.** When working with a large group, one of the most challenging tasks can be posing. In this case, I wanted to create dynamic poses that would fit the energetic mood of the setting, and of the dancers themselves. I also had to work with the fact that, although the women are all team members, some dancers had seniority and needed to be featured a bit more than others. When posing twenty people, it can be quite a challenge to give everybody the billing they deserve.

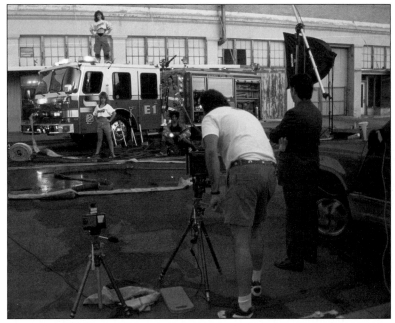

To the left is the final poster, above is a scene from the shoot.

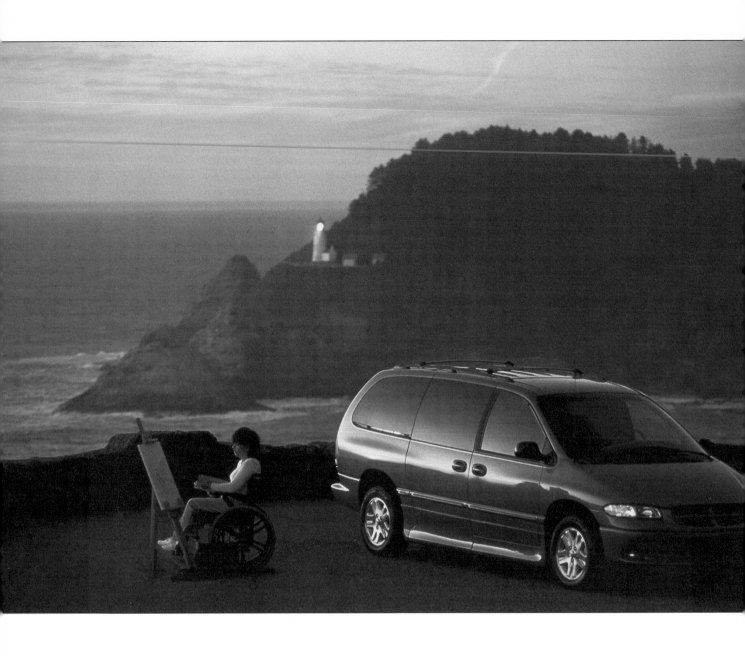

"The only problem was that there were incredibly high winds."

A company in Phoenix which adapts vans with wheelchair ramps used these images in their promotional materials. I've worked with the company for several years, and every year they have a little more money to spend and want to get a little more creative. This is a good example of how your photography business can grow along with the success of your local clients.

• **Location.** A location scout was used to find the spot. He provided us with specifications for several sites with lighthouses, and we picked this one. We secured the permits, had the model and everything was going well. The parking lot was even cordonned off with cones to keep people from parking and obstructing the shoot (we still had a fairly big crowd, since people generally like watching a photo shoot).

• **Adverse Weather.** The only problem was that there were incredibly high winds. We were using a 12' tripod to get the elevation needed for the shot, and this had to be sandbagged. Even with the bags, I ended up having to switch to a smaller format camera because the 4"x5" simply caught too much wind. I had an assistant holding the ladder from which I was shooting, and the painting had to be clamped to the easel. The important thing is that when you look at the resulting image, you don't see any of this.

Despite the adverse conditions, we were able to create the feel of a tranquil seaside sunset. A little digital manipulation was used later to erase the clamps from the painting, and to correct for the wind in the model's hair.

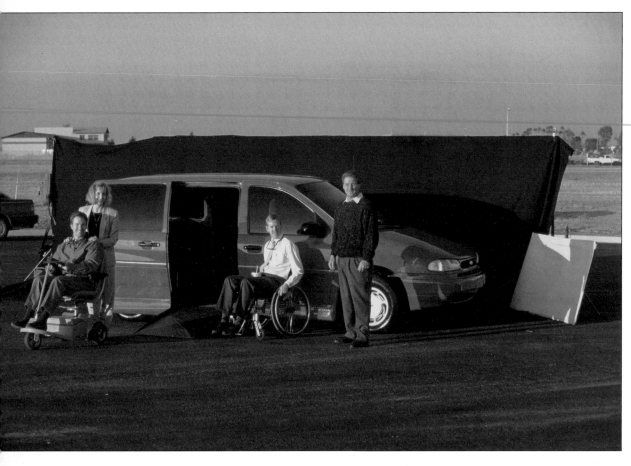

Ford offers
luxury air
suspension upg
for improved r
and handling.
Vantage includ
similar feature
every model, a
also provides a
"kneel" functic
for reduced rar
incline.

The image to the right was used by Vantage Mini Vans to promote their vans which are converted for the physically challenged. To see another project shot for this company, see page 103.

■ Vantage's power sliding door, which can now be opened manually from within or outside the vehicle, is an industry first. This is the safest and most convenient exit system on the market today.

■ Our optional sliding rear bench provides an additional 9 cubic feet of storage space at the rear of the van for groceries, supplies or those extended trips.

■ Choose between Vantage's premier Northstar system with its "invisible" in-the-floor slide out ramp, or our economical power or manual folding ramp models.

■ The modular removable front seats, with their unique tapered design, give the wheelchair user an additional 8 inches of maneuvering space.

■ Vantage's nationally acclaimed craftsmanship and quality materials blend seamlessly with Windstar's contoured cabin and sleek exterior design—from our streamlined ramp mechanisms, to our premium grade carpeting and hand-finished skirts.

■ The "lowered floor" conversion—perfected by Vantage Mini Vans—is coupled with Windstar's spacious interior to provide unparalleled maneuvering room for the wheelchair or scooter user.

■ VANTAGE MINI VANS, a name you can count on for exceptional quality and safety—year in and year out. Since our inception in 1987, we've been the industry leader in customer service and innovative design solutions.

■ With its elegant, wind-cutting design, Windstar is the perfect platform for a new era of handicapped accessible conversions. Continuing a legacy of quality and innovative design by Ford Motor Co., one of the world's largest and most respected automakers.

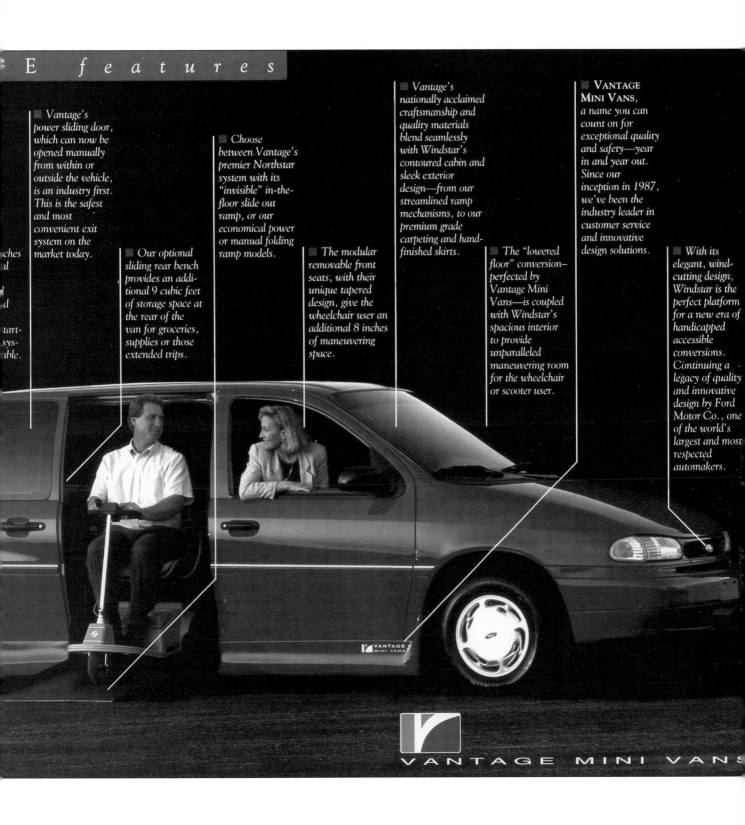

r VANTAGE MINI VANS

This image was shot for use in a brochure by the Bates USA Army campaign. The job required location scouting, as well as scouting to find a model who could do the shot.

• **Specialized Models.** Occasionally, you may need to find a model with specialized talents (here, a hiker) to fit a role where the model must really look like they know what they are doing. When casting a model like this, you may find it helpful to work with a modeling agency that specializes in athletic models. They can help you find everything from kayakers to high jumpers. If you are looking for local talent, you can also call a regular modeling agency and ask them for a model who can play tennis, or a model who is a runner. Make sure to try the model out – make sure they have the look and abilities you want.

• **Location Overuse.** Sometimes locations (especially readily identifiable ones such as the New York City skyline or the Eiffel Tower) can get overused. For instance, Merry-Go-Round Rock, in Sedona, Arizona, is a popular shooting spot – so popular in fact that you may have to wait in line to get on the grounds. Using different angles and being creative with your light can help to make these much-photographed spots look fresh.

Locations also go in and out of vogue, partly because of technology (such as the use of computers), and partly as a consequence of the many factors that must be considered in selecting a location. Physical access is an important factor, as is obtaining permission to shoot. Cost is also important, of course. Depending on the site, costs could vary from as little as $15 for a year of access (for a city park, perhaps) to as much as $2000 per day to shoot at a major resort. If you happen to be shooting on an Indian reservation, expect to pay up to $2500 to the tribe, as well as a fee to the individual landholder. Other financial factors in selecting a location include transportation to and from the site, and whether an overnight stay (or several nights' stay) will be required. You must also factor in food and rental vehicles, and multiply to account for the photographer, the model, the art director and any other assistants or executives who may be along on the shoot.

"Occasionally, you may need to find a model with specialized talents ..."

This was a big production piece, and an image I shot for my own promotion. It was inspired by a shot I had seen of an Indian family in a cave. When I saw the photo, I thought it would have been great if the father had been sitting there in his loincloth watching television. I made a mental note of the thought, and played on it in this image.

• **Location.** To create the photograph, I rented a truck and took the studio computer out into the desert. I also pre-arranged permission to shoot in the area and hired two members of the Navajo tribe to pose as my models. The spot I chose was one where the dirt road we drove in on would be completely hidden. This helped create the really old feel of the shot.

• **Weather.** The shoot took place in the middle of May, but surprisingly there was a snowstorm. Fortunately, the snow melted off the landscape, but it was still bitter cold and hard to work. The weather was so bad that the female model's eyes were watering and the tears froze to her face and had to be cracked off!

• **Digital Manipulation.** The actual screen was added digitally after the shoot. Today, if I were doing the shot again, I would probably haul a generator along with me and avoid the digital imaging. At the time, though, money was tight and the shoot was already getting expensive.

I think of this as my signature shot, and of all my work, I think this is probably the one that will last. It has been used for five or six different posters.

"It was inspired by a shot I had seen of an Indian family in a cave."

Iwas on a shoot for Scottsdale Tourism when I took this pho-tograph. The event was a huge bike race with hundreds of racers. I was set up in front of a dirt jump to get some shots of the bikers in mid-air as they came past.

Before the race, the bikers had to line up and walk through a slot, one at a time, so the judges could get their numbers. In order to make it through the slot, they had to hold their bikes up over their heads.

As soon as I caught sight of the athletes with their bikes over-head, I knew I had to get the shot. I grabbed a 500mm lens, darted across the track, and started shooting.

• **Stock Photography.** This is a perfect image to use for stock, since none of the athletes are clearly identifiable. I've sold it for use on a cigarette billboard.

"This is a perfect image to use for stock ..."

Making it Memorable

When going out on a shoot, we always prepare a packet for the art director. This usually includes a shot list, and a pro-duction list, as well as things like suntan oil, bottled water, etc. This gesture goes a long way toward making the experi-ence a fun one for the art director, and convincing him you are right for the shoot. When people hire you for a shoot, they're not just hiring you for the photography. In some ways, they are hiring you for "the ride" – the experience of the shoot and the whole package. Advertising photography is really about 40% photography and 60% creating that package. After a good shoot, you may want to put together a sheet of produc-tion stills for the client – a token of the shoot. The photo shown here is a still from the shoot dis-cussed in more detail on page 93.

When I had a vision of a photograph that would contrast old and new technology, I sketched it out on a napkin to lock it in my head. The points of contrast are the high-tech sports car and the low-tech African tribesmen. It was shot on the pure white salt flats, and we worked late in the day to get these long shadows.

"Reps need new product all the time ..."

• **The Shoot.** This was a shot that I did for myself, not a client. I paid a $250 location fee and had a forklift come in so that I could shoot down on the scene from the right angle. I paid three models $150 dollars each for the day. They were dressed in sandals and wrapped in cloth. The car (a Dodge Stealth) was volunteered by a local DJ in return for photographs.

Doing test shooting for yourself is very important. Reps need new product all the time, and when they have new images they will be more willing to show your work around. Test shoots you do for yourself can also turn into productive images for stock. One image from the shoot sold for the cover of an Italian tourism magazine (see below).

Doing test shooting for yourself is very important. Reps need new product all the time, and when they have new images they will be more willing to show your work around. Test shoots also give you time to experiment with different techniques and subjects — such as the interesting combination of old and new in this image. To read more about the shoot, turn to page 113.

Years ago, Dial's original ad campaign for Breck used a "Breck Girl" (who served for one year) in a pastel likeness. When they decided to resurrect the "Breck Girl" idea, it was in an updated form. Dial held a contest to select three "Breck Girls" – one a teenager, one in her twenties or thirties, and one in her forties.

• **The Shoot.** When we did the shoot, they wanted just the women (no complicated backgrounds or special effects), and spent a lot of time getting the women's hair and make-up just perfect. No expense was spared – all the company executives were there, and there was music and catered food. In fact, the shoot became something of a public relations event. I was even wired for the coverage by *American Journal* (although I showed up in the televised story for only a second or two).

All in all, it was a simple head shot. The company spent a lot of money on the project, but most of it went into the "performance" that surrounded the shoot, rather than on the photography itself.

" ... the shoot itself became something of a public relations event."

BRECK®
Salon Essentials™
Natural Formula

Introducing Breck *Salon Essentials* and the 1995 Breck Girls – Page, Tiffanie and Sandi.

Naturally not all hair is alike. That is why Breck *Salon Essentials* was created. One of Breck's carefully developed haircare products is all you need to be a Breck Natural Beauty.

Breck *Salon Essentials* are high performance, salon formulations enriched with essential natural herbs, proteins and vitamins that help reveal your hair's natural texture and shine. Just ask a Breck Girl.

Beautiful Hair Naturally™

©1995 The Dial Corp

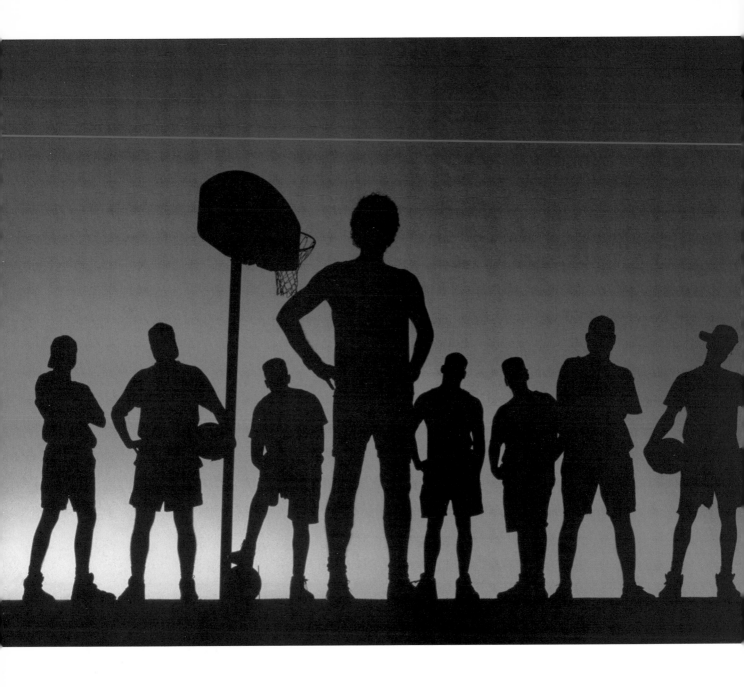

This shoot was done on a very restricted budget. The art director wanted a basketball team silhouetted against a sunrise or sunset. The background needed to be totally clear.

• **Models**. Since there was no money to spend on models, I turned to a local boys' and girls' club for my players. I gave $200 to the club and got six kids for the shoot. They were shot in street clothes.

• **Location.** The location was also a little tricky. I had to find a place that faced west (we decided on a sunset shot to fit the models' schedules), and was unobstructed. Finally, we found a freeway overpass that was still being built and didn't have sidewalls yet. Permission to shoot was secured from the highway department.

We set up a hoop on the road, and using a sunset filter, I placed the camera on the edge of the road and took the shot. It was a real problem-solving situation.

"Finally, we found a freeway overpass that was still being built ..."

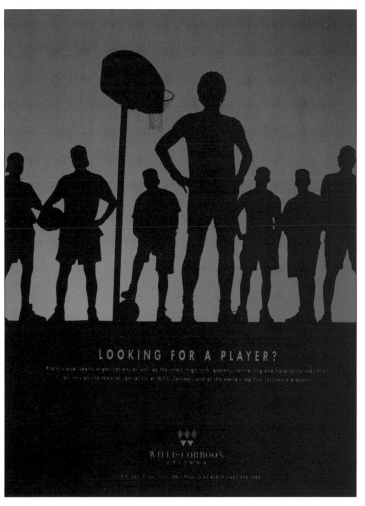

Excess Media Baggage Charges and Airline Codes

Most airlines limit luggage pieces or set weight restrictions. Occasionally it may be cheaper to buy an extra seat (and the accompanying complimentary luggage space) than pay the extra luggage fees. Most airlines do accommodate film and media crews with a reduced rate for excess luggage. Counter people are usually familiar with the computer codes that allow you these reduced rates. The following is a current list of allowances and codes to help pave your way. For unlisted airlines, call a supervisor and you should be able to get the information you need.

Alaska
800-426-0333
First three bags free,
Four+ bags $35.00
Weight limit: 70 lbs limit/bag

America West Airlines
800-235-9292
First two bags free
Three+ bags $35.00 unlimited
Code: "ggbagcost G (display) 69"

American Airlines
800-443-7300
First three bags free
Four+ bags $35.00 unlimited
Size limit: 115 inches
Code: "N DBAG 190"

Continental
800-525-0280
First three bags free
Four+ bags $45.00 unlimited

Delta
800-221-1212
First three bags free
Four+ bags $35.00 unlimited
Code: G-Baggage Page 15 Line 37

Frontier Airlines
800-432-1359
First three bags free
Four+ bags $20.00 unlimited

North West Airlines
800-447-4747
First three bags free
Four+ bags $35.00

Southwest Airlines
800-435-9792
First three bags free
Four+ bags $20.00 unlimited

TWA
800-221-2000
First three bags free
Four+ bags $20.00
Code: G/APS/BAG Page 6

United
800-241-6522
First three bags free
Four+ bags $25.00 unlimited
Code: S*BAG/MISC CAMERA EQUIP

US Air
800-428-4322
First three bags free
Four+ bags $35.00 unlimited
Code: H/Excess baggage line 84

Film Commissions

Location scouting and obtaining permits are an important part of preparing for a shoot. The film commissions listed below can be a great resource in this process. Listed below are the film commissions for each of the states in the United States.

Alabama Film Office

401 Adams Avenue
Montgomery, AL 36130
Phone: (800) 633-5898
Fax: (205) 242-2077

Alaska Film Office

3601 C Street, Suite 700
Anchorage, AK 99503
Phone: (907) 562-4163
Fax: (907) 563-3575

Arizona Film Commission

3800 N. Central Avenue, Bldg. D
Phoenix, AZ 85012
Phone: (800) 523-6695, (602) 280-1380
Fax: (602) 280-1384

Arkansas Motion Picture Development Office

1 State Capital Mall, Room 2C-200
Little Rock, AR 72201
Phone: (501) 682-7676
Fax: (501) 682-FILM

California Film Commission

6922 Hollywood Blvd., Suite 600
Hollywood, CA 90028-6126
Phone: (800) 858-4PIX, (213) 736-2465
Fax: (213) 736-2522

Colorado Springs Film Commission

30 S. Nevada Avenue, Suite 405
Colorado Springs, CO 80903
Phone: (719) 578-6943
Fax: (719) 578-6394

Connecticut Film, Video & Media Office

865 Brook Street
Rocky Hill, CT 06067
Phone: (203) 258-4339
Fax: (203) 529-0535

Delaware Film Office

99 Kings Highway, P.O. Box 1401
Dover, DE 19903
Phone: (800) 441-8846, (302) 739-4271
Fax: (302) 739-5749

Florida Entertainment Commission

505 17th Street
Miami Beach, FL 33139
Phone: (850) 224-0982

Georgia Film & Videotape Office

285 Peachtree Center Avenue, Suite 1000
Atlanta, GA 30303
Phone: (404) 656-3591
Fax: (404) 651-9063

Hawaii Film Office

P.O. Box 2359
Honolulu, HI 96804
Phone: (808) 586-2570
Fax: (808) 586-2572

Idaho Film Bureau

700 W. State Street, 2nd Floor, Box 83720
Boise, ID 83720-0093
Phone: (800) 942-8338, (208) 334-2470
Fax: (208) 334-2631

Illinois Film Office
100 W. Randolph, Suite 3-400
Chicago, IL 60601
Phone: (312) 814-3600
Fax: (312) 814-6175

Indiana Film Commission
1 North Capitol, #700
Indianapolis, IN 46204-2288
Phone: (317) 232-8829
Fax: (317) 233-6887

Iowa Film Office
200 E. Grand Avenue
Des Moines, IA 50309
Phone: (515) 242-4726
Fax: (515) 242-4859

Kansas Film Commission
700 SW Harrison Street, Suite 1300
Topeka, KS 66603
Phone: (913) 296-4927
Fax: (913) 296-6988

Kentucky Film Commission
500 Mero Street, 2200 Capitol Plaza Tower
Frankfort, KY 40601
Phone: (800) 345-6591, (502) 564-3456
Fax: (502) 564-7588

Louisiana Film Commission
P.O. Box 44320
Baton Rouge, LA 70804-4320
Phone: (504) 342-8150
Fax: (504) 342-7988

Maine Film Office
State House Station 59
Augusta, ME 04333
Phone: (207) 287-5707
Fax: (207) 287-5701

Maryland Film Commission
601 N. Howard Street
Baltimore, MD 21201-4582
Phone: (800) 333-6632, (410) 333-6633
Fax: (410) 333-0044

Massachusetts Film Office
10 Park Plaza, Suite 2310
Boston, MA 02116
Phone: (617) 973-8800
Fax: (617) 973-8810

Michigan Film Office
525 W. Ottawa, P.O. Box 30004
Lansing, MI 48933
Phone: (800) 477-3456, (517) 373-0638
Fax: (517) 373-3872

Minnesota Film Board
401 N. 3rd Street, Suite 460
Minneapolis, MN 55401
Phone: (612) 332-6493
Fax: (612) 332-3735

Mississippi Film Office
Box 849
Jackson, MS 39205
Phone: (601) 359-3297
Fax: (601) 359-5757

Missouri Film Office
301 West High, #630, P.O. Box 118
Jefferson City, MO 65102
Phone: (314) 751-9050
Fax: (314) 751-7384

Montana Film Office
1424 9th Avenue
Helena, MT 59620
Phone: (800) 553-4563, (406) 444-2654
Fax: (406) 444-1800

Nebraska Film Office
P.O. Box 94666
Lincoln, NE 68509-4666
Phone: (800) 228-4307, (402) 471-3797
Fax: (402) 471-3026

Nevada
Motion Picture Division/Commission on
Economic Development
555 E. Washington, Suite 5400
Las Vegas, NV 89101
Phone: (702) 486-2711
Fax: (702) 486-2712

North Carolina Film Office
430 N. Salisbury Street
Raleigh, NC 27611
Phone: (800) 232-9227, (919) 733-9900
Fax: (919) 715-0151

North Dakota Film Commission
604 East Blvd., 2nd Floor
Bismarck, ND 58505
Phone: (800) 328-2871, (701) 328-2874,
(701) 328-2525
Fax: (701) 328-4878

Ohio Film Commission
77 S. High Street, 29th Floor, P.O. Box 1001
Columbus, OH 43266-0413
Phone: (800) 848-1300, (614) 466-2284
Fax: (614) 466-6744

Oklahoma Film Office
440 S. Houston, Suite 4
Tulsa, OK 74127-8945
Phone: (800) 766-3456, (918) 581-2660
Fax: (918) 581-2244

Oregon Film & Video Office
121 SW Salmon Street, Suite 300
Portland, OR 97204
Phone: (503) 229-5832
Fax: (503) 229-6869

New Hampshire Film & TV Bureau
172 Pembroke Road, P.O. Box 1856
Concord, NH 03302-1856
Phone: (603) 271-2598
Fax: (603) 271-2629

New Jersey Motion Picture/TV Commission
153 Halsey Street, P.O. Box 47023
Newark, NJ 07101
Phone: (201) 648-6279
Fax: (201) 648-7350

New Mexico Film Office
1050 Old Pecos Trail
Santa Fe, New Mexico 87501
Phone: (505) 827-7365
Fax: (505) 827-7369

New York State Governor's Office/Motion Picture-TV Development
Pier 62 W 23rd Street at Hudson River, #307
New York, NY 10011
Phone: (212) 929-0240
Fax: (212) 929-0506

Pennsylvania Film Bureau
Forum Bldg., #449
Harrisburg, PA 17120
Phone: (717) 783-3456
Fax: (717) 234-4560

Puerto Rico Film Commission

355 F.D. Roosevelt Ave., Fomento Bldg. #106
San Juan, PR 00918
Phone: (809) 758-4747, ext. 2250-57
Fax: (809) 756-5706

South Carolina Film Office

P.O. Box 7367
Columbia, SC 29202
Phone: (803) 737-0490
Fax: (803) 737-3104

South Dakota Film Commission

711 E. Wells Avenue
Pierre, SD 57501-3369
Phone: (800) 952-3625, (605) 773-3301
Fax: ((605) 773-3256

Tennessee Film/Entertainment/ Music Commission

320 6th Avenue North, 7th Floor
Nashville, TN 37243-0790
Phone: (800) 251-8594, (615) 741-3456
Fax: (615) 741-5829

Texas Film Commission

P.O. Box 13246
Austin, TX 78711
Phone: (512) 463-9200
Fax: (512) 463-4114

U.S. Virgin Islands Film Promotion Office

P.O. Box 6400
St. Thomas, V.I. 00804, U.S.V.I.
Phone: (809) 775-1444, (809) 774-8784
Fax: (809) 774-4390

Utah Film Commission

324 S. State, Suite 500
Salt Lake City, UT 84114-7330
Phone: (800) 453-8824, (801) 538-8740
Fax: (801) 538-8886

Virginia Film Office

901 E. Byrd Street, 19th Floor, P.O. Box 798
Richmond, VA 23206-0798
Phone: (804) 371-8204
Fax: (804) 371-8177

Washington DC

Mayor's Office of Motion Picture & TV
717 4th Street, N.W., 12th Floor
Washington, DC 20005
Phone: (202) 727-6600
Fax: (202) 727-3787

Washington State Film & Video Office

2001 6th Avenue, Suite 2600
Seattle, WA 98121
Phone: (206) 464-7148
Fax: (206) 464-7222

West Virginia Film Office

State Capital, Bldg. 6, Room 525
Charleston, WV 25305-0311
Phone: (800) 982-3386, (304) 558-2234
Fax: (304) 558-1189

Wisconsin Film Office

123 W. Washington Avenue, 6th Floor
Madison, WI 53702-0001
Phone: (608) 267-3456
Fax: (608) 266-3403

Wyoming Film Commission

I-25 and College Drive
Cheyenne, WY 82002-0240
Phone: (800) 458-6657, (307) 777-7777
Fax: (307) 777-6904

Index

Models
 non-professional, 75, 113, 119
 professional, 86
 scouting, 93
 specialized, 93, 106
 working with, 86
Motion, 60, 80, 95

P

Polaroid transfer, 5, 42, 52
Portfolio, 10-12
 customizing, 10-11, 76
 design, 10-11
 image format, 11
 image selection, 10, 62
 shipping, 12, 15-16
 weight, 12
Posing, 50
Print collateral campaigns, 90
Processing film, 78
Production, 16-23, 48
 assistants, free-lance, 21-22
 assistants, full-time, 22-23
 location scouting, 19
 make-up, 20-21, 116
 permits, 19
 production coordinators, 23
 propping, 20
 stylists, 20
Production value, 16
Promotions, 6-10

R

Renting
 equipment, 24
 studio, 24, 50
Representatives, 8-9, 37
 benefits, 9
 choosing, 9
 fees, 9
Rights to images, 38, 44

S

Selective focus, 32,42
Smoke machine, 54
Snip tests, 78
Spanish language markets, 57
Stock photography, 42, 50, 76, 80, 95, 110, 113
Studio
 location, 75
 promoting, 75
Style, 5, 70, 95
Submitting images to client, 60

T

Tape, 80
Tear sheets, 62
Test rolls, 78
Test shoots, 75, 76, 95, 113

U

Usage, 16

W

Weather, 32, 44, 95, 108
Workbook, 6

Other Books from Amherst Media, Inc.

Basic 35mm Photo Guide

Craig Alesse

Great for beginning photographers! Designed to teach 35mm basics step-by-step — completely illustrated. Includes: 35mm automatic and semi-automatic cameras, camera handling, ƒ-stops, shutter speeds, and more! $12.95 list, 9x8, 112p, 178 photos, order no. 1051.

Build Your Own Home Darkroom

Lista Duren & Will McDonald

This classic book shows how to build a high quality, inexpensive darkroom in your basement, spare room, or almost anywhere. Information on: darkroom design, woodworking, tools, and more! $17.95 list, 8½x11, 160p, order no. 1092.

Into Your Darkroom Step-by-Step

Dennis P. Curtin

The ideal beginning darkroom guide. Easy to follow and fully illustrated each step of the way. Information on: equipment you'll need, set-up, making proof sheets and much more! $17.95 list, 8½x11, 90p, hundreds of photos, order no. 1093.

Camera Maintenance & Repair

Thomas Tomosy

A step-by-step, fully illustrated guide by a master camera repair technician. Sections include: testing camera functions, general maintenance, basic tools needed, basic repairs for accessories, camera electronics, plus "quick tips" for maintenance and more! $24.95 list, 8½x11, 176p, order no. 1158.

Camera Maintenance & Repair Book 2

Thomas Tomosy

Advanced troubleshooting and repair building on the basics covered in the first book. Includes; mechanical and electronic SLRs, zoom lenses, medium format, troubleshooting, repairing plastic and metal parts, and more. $29.95 list, 8½x11, 176p, 150+ photos, charts, tables, appendices, index, glossary, order no. 1558.

Restoring Classic & Collectible Cameras

Thomas Tomosy

A must for camera buffs and collectors! Clear, step-by-step instructions show how to restore a classic or vintage camera. Work on leather, brass and wood to restore your valuable collectibles. $34.95 list, 8½x11, 128p, b&w photos and illustrations, glossary, index, order no. 1613.

McBroom's Camera Bluebook

Mike McBroom

Comprehensive, fully illustrated, with pricing on: 35mm cameras, medium & large format cameras, exposure meters, strobes and accessories. Pricing info based on equipment condition. A must for any camera buyer, dealer, or collector! $34.95 list, 8½x11, 224p, 75+ photos, order no. 1263.

Infrared Photography Handbook

Laurie White

Covers b&w infrared photography: focus, lenses, film loading, film speed rating, heat sensitivity, batch testing, paper stocks, and filters. Photos illustrate IR film use in portrait, landscape, and architectural photography. $24.95 list, 8½x11, 104p, 50 b&w photos, charts & diagrams, order no. 1419.

The Art of Infrared Photography / 4th Edition

Joe Paduano

A practical, comprehensive guide to infrared photography. Tells what to expect and how to control results. Includes: anticipating effects, color infrared, digital infrared, using filters, focusing, developing, printing, handcoloring, toning, and more! $29.95 list, 8½x11, 112p, order no. 1052.

Infrared Nude Photography

Joseph Paduano

A stunning collection of images with informative how-to text. Over 50 infrared photos presented as a portfolio of classic nude work. Shot on location in natural settings, including the Grand Canyon, Bryce Canyon and the New Jersey Shore. $29.95 list, 8½x11, 96p, over 50 photos, order no. 1080.

Handcoloring Photographs Step-by-Step

Sandra Laird & Carey Chambers

Learn to handcolor photographs step-by-step with the new standard handcoloring reference. Covers a variety of coloring media. Includes colorful photographic examples. $29.95 list, 8½x11, 112p, 100+ color and b&w photos, order no. 1543.

Black & White Model Photography

Bill Lemon

On location or in the studio, learn the techniques of a professional model photographer. Posing, lighting, equipment, model selection and composition are included. $29.95 list, 8½x11, 120p, 50+ b&w photos, order no. 1577.

Fine Art Portrait Photography

Oscar Lozoya

The author examines a selection of his best photographs, and provides detailed technical information about how he created each. Lighting diagrams accompany each photograph. $29.95 list, 8½x11, 128p, 58 photos, index, order no. 1630.

Achieving the Ultimate Image

Ernst Wildi

Ernst Wildi shows how any photographer can take world class photos and achieve the ultimate image. Features: exposure and metering, the Zone System, composition, evaluating an image, and much more! $29.95 list, 8½x11, 128p, 120 B&W and color photos, index, order no. 1628.

Lighting Techniques for Photographers

Norman Kerr

Learn to identify light qualities and control them to create dramatic images. Covers filters, choice of equipment, processing and composition for B&W and color images. $29.95 list, 8½x11, 120p, 100 B&W and color photos, index, order no. 1564.

Black & White Portrait Photography

Helen Boursier

Make money with B&W portrait photography. Learn from top B&W shooters! Studio and location techniques, with tips on preparing your subjects, selecting settings and wardrobe, lab techniques, and more! $29.95 list, 8½x11, 128p, 130+ photos, index, order no. 1626.

Profitable Portrait Photography

Roger Berg

Learn to profit in the portrait photography business! Improves studio methods, lighting techniques and posing, and tells how to get the best shot quickly. A step-by-step guide to making money. $29.95 list, 8½x11, 104p, 120+ B&W and color photos, index, order no. 1570.

Family Portrait Photography

Helen Boursier

Tells how to operate a successful family portrait studio, including marketing family portraits, advertising, working with clients, posing, lighting, and selection of equipment. $29.95 list, 8½x11, 120p, 123 photos, index, order no. 1629.

Stock Photography

Ulrike Welsh

This book provides an inside look at the business of stock photography. Explore photographic techniques and business methods that will lead to success shooting stock photos — creating both excellent images and business opportunity. $29.95 list, 8½x11, 120p, 58 photos, order no. 1634.